Images of Modern America

STAGING THE GREAT CIRCUS PARADE

Jim and Donna Peterson

Copyright © 2016 by Jim and Donna Peterson
ISBN 978-1-4671-1573-5

Published by Arcadia Publishing
Charleston, South Carolina

Printed in the United States of America

Library of Congress Control Number: 2015948414

For all general information, please contact Arcadia Publishing:
Telephone 843-853-2070
Fax 843-853-0044
E-mail sales@arcadiapublishing.com
For customer service and orders:
Toll-Free 1-888-313-2665

Visit us on the Internet at www.arcadiapublishing.com

Dedicated to the hundreds of volunteers over the years who made this parade a safe, memorable family event—Down the Road!

Images of Modern America

STAGING THE
GREAT CIRCUS PARADE

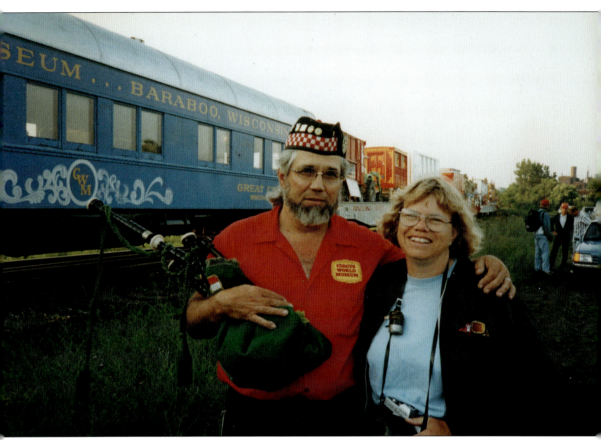

Jim Peterson began volunteering for the circus parades right out of high school, putting banners on wagons. Donna Peterson's volunteering began by providing cold water to hot train crew workers and putting banners on wagons. Fascinated by the activity behind the scenes, and not being types to sit and watch the parade pass them by, they—with their three children—spent summer vacations every year working hard and loving every minute of it. (Photograph by George Cutlip.)

FRONT COVER: Tu-Tall the Giraffe parades by (page 75). (Authors' collection.)

UPPER BACK COVER: 1985 Staging Grounds (page 27). (Authors' collection.)

LOWER BACK COVER (FROM LEFT TO RIGHT): Mr. Bill the clown (page 19), Kathy Hayes buckled in (page 67), Caravan of circus wagons (page 83). (All, authors' collection.)

CONTENTS

Acknowledgments		6
Introduction		7
1.	Heading Out	9
2.	Parade Grounds	25
3.	Parade Day	57
4.	Heading Home	77

Acknowledgments

Re-creating the circus parades of old was the brainchild of Charles Phillip "Chappie" Fox. He approached Benjamin "Ben" Barkin to pitch the idea to a Milwaukee sponsor. Robert "Bob" Uhlein of the Joseph Schlitz Brewing Company stepped up to the plate, and the parade was born. We will be forever grateful to their foresight in providing a free, fun, family venue that was enjoyed by children of all ages.

We would also like to acknowledge Robert "Bob" Parkinson, the former Circus World Museum chief librarian, for reviving the parade and personally inviting Jim Peterson to volunteer and allowing his family to tag along.

We owe the Circus World Museum staff—former employees Frankie Braun, Keri Olson, Rick Percy, Tim Perkins, Greg Parkinson, and Dale Williams; along with current employees Scott O'Donnell, Circus World executive director; David Saloutos, performance director; Peter Shrake, Circus World archivist; and Heavy Burdick, wagon master—for enthusiastically supporting this project.

We worked side by side with literally hundreds of fantastic volunteers. We wish we could name you all.

Unless indicated otherwise, all photographs are from the authors' collection.

INTRODUCTION

In the early 1900s, Wisconsin was home to over 100 circuses. The Ringling brothers' show started out in Baraboo, Wisconsin. Chappie Fox was fascinated by horses, trains, and circuses. He was an avid photographer and took many pictures of his three favorite subjects. His own circus collection included the Mother Goose wagon. With support from John M. Kelly, a lawyer who worked for Ringling Bros., Chappie worked to start a circus museum in Baraboo. Circus World Museum opened in 1957, and the grounds encompassed the buildings along the Baraboo River that were originally constructed by Ringling Bros. for its animals and workshops for winter quarters.

Chappie felt the best way to show off the growing circus wagon collection was to stage a parade, which would bring recognition not only to the museum but also to the state. He knew circus fans from all over the country would come out for an old-fashioned parade. Chappie's vision was embraced by Ben Barkin, a marketing and advertising genius who put Chappie in touch with Bob Uhlein of the Schlitz Brewing Company. Schlitz provided the financing to produce the first run of Milwaukee parades from 1963 to 1972.

Circuses always fascinated coauthor Jim Peterson. His dad took him to any show that traveled into town. When foot surgery laid him up for an entire summer as a young boy, his dad brought him circus models and animals and he began his half-inch scale model circus. In 1963, a circus parade of days gone by was staged in Milwaukee, Wisconsin, by Circus World Museum of Baraboo. Peterson jumped at the chance to volunteer with the full-scale wagons. He was a teenager back when he started volunteering on the flags and banners crew. The parade was scheduled for July 4, and it became a yearly Milwaukee family tradition, as common for Wisconsinites as state fair cream puffs. Free circus acts were staged on the lakefront prior to the Fourth of July. The baby boomer parents of that day were too young to remember turn-of-the-century circus parades. The city parents never saw six-, eight-, and ten-hitch draft horses pulling circus wagons. A piece of history was brought to life, and the city of Milwaukee embraced the event. Circus World Museum paraded its wagon collection down Wisconsin Avenue to thousands of spectators, and every year it grew with new costumes, wagons, and sections. During the first parades, the wagons were trucked into town. Later wagons came by rail. The fledgling Circus Museum obtained the largest collection of circus wagons in the world. Many came in disrepair, and through the parade backing and recognition, funds were found to bring the old wagons back to life. The museum gained national recognition with the one-of-a-kind parade. It was important to find financial backing.

The first run of parades ended in 1972. The major financial sponsor, Joseph Schlitz Brewing Company, backed out and eventually left the state in a merger. The museum continued looking for sponsorship for the parade. In 1980, the Baraboo community staged a small-scale parade in the town. Needing experienced volunteers, Bob Parkinson asked Jim Peterson if he would again help out with parade marshaling duties, nighttime guard duty, and other tasks. Jim said yes, as long as his young family could come along. Parkinson said all volunteers were welcome to camp on the Sauk County Fairgrounds in Baraboo. A family tradition was started.

Jim and Donna Peterson so enjoyed that first parade that, the next summer, they started making the 119-mile trip from Milwaukee to Baraboo every Friday night. Jim volunteered on the Circus World Museum grounds, working with the horse department. Eventually, Parkinson learned that Jim played saxophone, and a new task was added. Jim now played for all circus performances and helped with the horses for the loading and unloading demonstration.

In 1981 and 1982, the parade was funded by the City of Chicago. Wherever the parade went, the Peterson family went. It was scheduled to kick off the Chicago summer events and was held on Memorial Day weekend. Jim was part of the train crew, and the family camped on Navy Pier. In 1983, Chicago city politics changed, and the new regime cancelled the parade a few months before it was scheduled. There were all sorts of rumors of taking the circus parade "on the road" to other cities that year and the following year, when the parade was held back in Baraboo. Fortunately, Ben Barkin—whose advertising and marketing firm put Chappie Fox in contact with Robert Uhlein back in the 1960s for the first run of the parade—was passionate about the parade returning to Milwaukee. Barkin was responsible for the creation of the Great Circus Parade Foundation, Inc. The foundation's mission was to annually produce an authentic re-creation of circus street parades of years gone by.

While many beautiful books were written about the parade itself, the Petersons realized that a lot of the work behind the scenes went undocumented. Setting up in a small city with approximately 70 circus wagons, over 600 horses, exotic animals, and hundreds of volunteers was a mammoth undertaking.

The 17 flatcars that carried circus wagons no longer travel through the countryside en route to a parade destination. Today, there is only one circus, Ringling Bros. and Barnum & Bailey, that moves its units by rail. They are not loaded by horse teams as in days gone by. The mammoth parade staged in Milwaukee over the latter half of the 20th century could only happen in Wisconsin. It was an annual family tradition for all the volunteers who worked the parade and an annual family tradition for all the spectators. Families would literally camp out the night before the parade on the sidewalk to have excellent viewing spots. The sights, sounds, and smells appealed to children of all ages.

One

Heading out

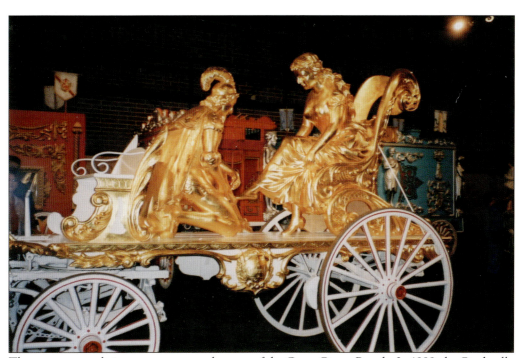

The ornate carved circus wagons were the stars of the Great Circus Parade. In 1999, the Cinderella tableau wagon was covered entirely in gold leaf. It shines under the spotlights at home in Baraboo, Wisconsin, but in the sunlight on parade days, it sparkled. This is one of three fairy tale tableau wagons. The other two depicted Mother Goose and the Old Woman Who Lived in the Shoe.

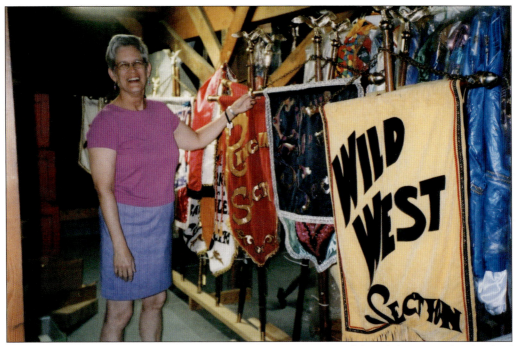

Gretchen Roltgen was wardrobe mistress from 2003 to 2009. All band, horse, and individual costumes were stored in the wardrobe building at Circus World. Here, she explains to a group in for band costume fittings the various banners that lead off the parade sections. Costumes traveled to Milwaukee by circus wagons and semitrailer.

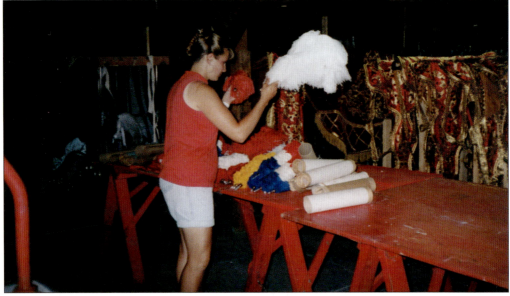

Plumes were kept clean by storing in round cardboard tubes. They were sorted by color and size, with large tubes for draft horses and small for pony hitches. Main plume colors were gold, red, white, or a tricolor red, white and blue. Every teamster received a hitch box with plumes, metal shafts for attaching plumes to harnesses, and Vicks VapoRub, which was rubbed in the horses' noses to block the smell of caged wild animals. In this photograph, Robin Peterson checks plumes.

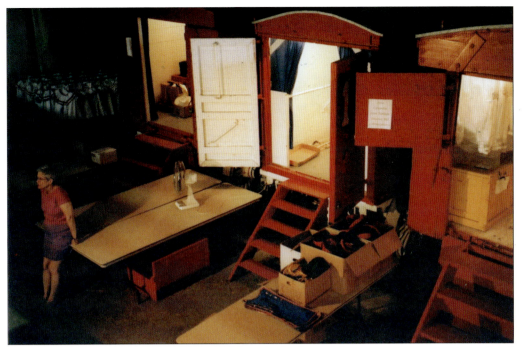

Wagons are lined up in the wardrobe building for loading. After, costumes were assigned and labeled with individual parade participant names and hung in the wagons. When a wagon was full, all costumes were tied down to prevent the rocking train motion from bringing them down. They were hung over wooden and cardboard boxes full of hats, shoes, gloves, and all needed props. The wooden stairs and chairs were the last items loaded in. Several of the wardrobe wagons had metal brackets on the outside walls, where the tables were tied down for travel. Gretchen Roltgen supervised the volunteers as they worked into the night preparing the wagons for train loading.

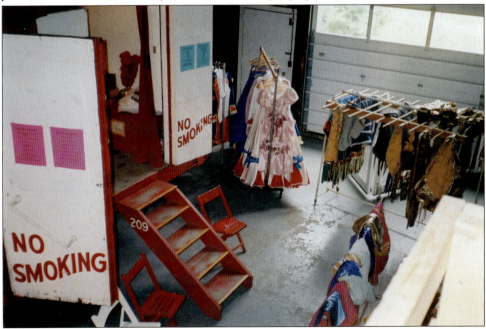

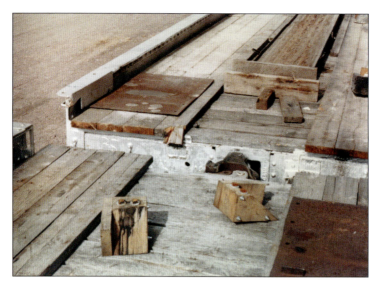

Metal crossover plates on the opposite sides of each flatcar were used to bridge the open flatcar gap when loading and unloading. Plates were three-by-four-foot, half-inch steel. The four corners of each plate were turned down to better grip the wooden decks. Bent corners kept the plates from moving as wagons rolled over. Wooden chock blocks were placed before the front and behind the back wheels for stability.

The crossover plate was placed in position to span the space over the couplers. After the empty flats were spotted, they were pushed by the engine to eliminate the slack between each coupler. Once the crew member was satisfied, he moved quickly out of the way and let the plate fall into position.

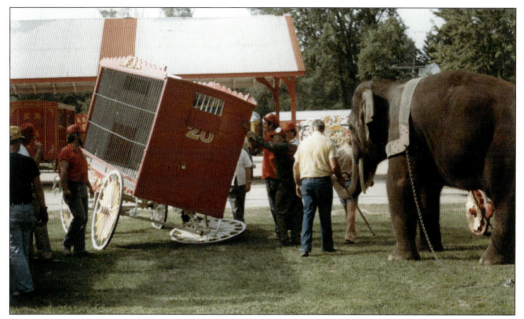

Cage No. 20 broke down prior to loading. The cage was empty and on Circus World Museum grounds in Baraboo when the mishap occurred. It was repaired in the wagon shop and returned to the loading lineup. While inconvenient, the breakdown occurred in the most convenient location.

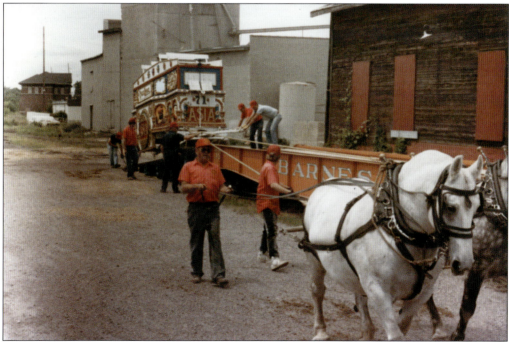

The teamster guides the pull-up team forward to load. The hook roper looks backwards, keeping the pull line free, while two polers steer the wagon by pulling or pushing on the wagon tongue. Heavier wagons required two polers for safety. The wagon master watches intently and signals go or stop commands by whistle. The crew member at the end uses a snatch block to wedge under the wheel if the wagon starts rolling backwards.

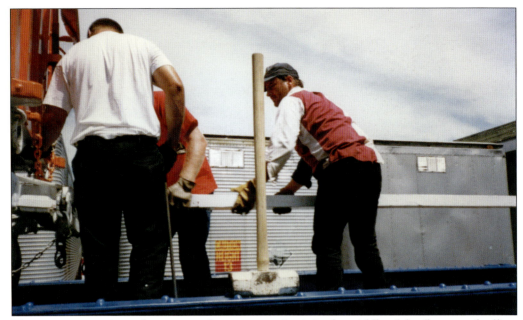

The train crew removes the wagon pole prior to setting it in the middle of the flatcar and rolling the wagon above it. Once the wagon is in position, the wheels will be chocked. The maul is used to firm up the wheel chocks against the wheels.

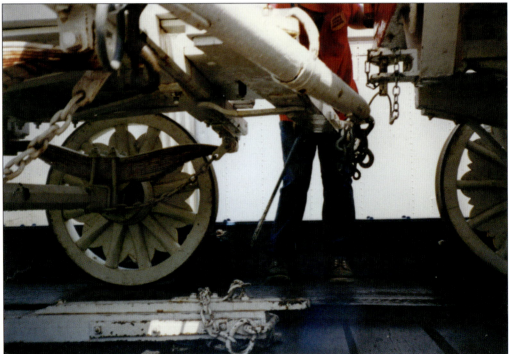

The wagon pole is under the wagon, and when the front wheel chocks are set, a short blast on the whistle will signal the chocking horse team to tug on the rope. Seated behind each rear wagon wheel are two train crew members. At the whistle blast, they would push the rear chocks into place with their feet, which will lock the wagon into position for travel.

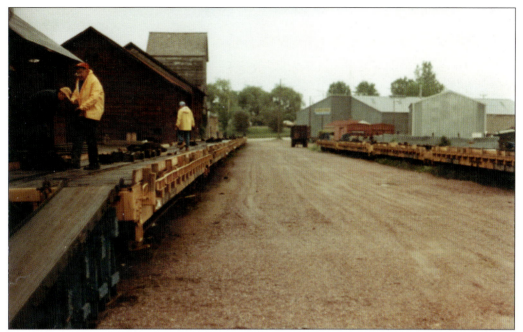

In 1981 and 1982, system flatcars were used to move the parade to Chicago. The length and placement of the circus flatcar wheels could not negotiate the tight turns in Chicago. Edward "Ed" Lester is positioning wheel chocks in the center of the car. System flats did not have side rails, so wooden rails were added to guide and keep the wagons from rolling off the sides.

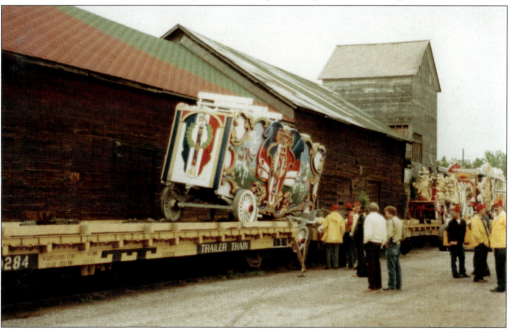

While loading the France bandwagon, the right crossover plate slipped off the flatcar. A construction crane was brought in, and a cloth sling was placed under the wagon and connected to the crane, which gently lifted it into place. There was no damage to the wagon, and the crossover plate was realigned and loading continued.

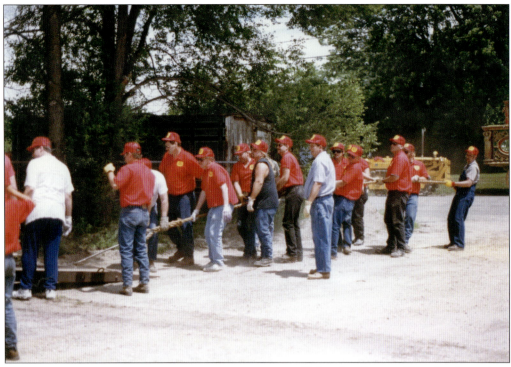

Before loading could begin, the train crew attached a hook rope to the first of the two runs and manually pulled it off the empty flatcar. The entire crew lifted the run by hand and placed it on one of the gunnels, or side rails. The process was repeated with the second run.

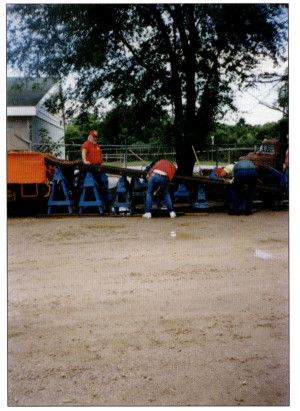

The runs were positioned to the flat. The supporting jacks were leveled and adjusted to the proper height with small blocks of wood. Once the jacks were snug, loading began. Wagons loaded up the run car and moved down the string of empty flats. When all but the run car were loaded, the string was uncoupled from the run car, and the next string of empty flats was brought in.

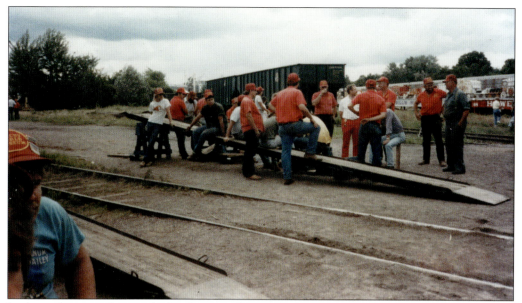

In the early years, the runs had to be moved every time a string of six flats was loaded. The runs were lifted to either side of the tracks, and a switch engine moved the loaded cars to a siding. The engine brought in another empty string of flats, the runs were relocated and jacked, and loading resumed.

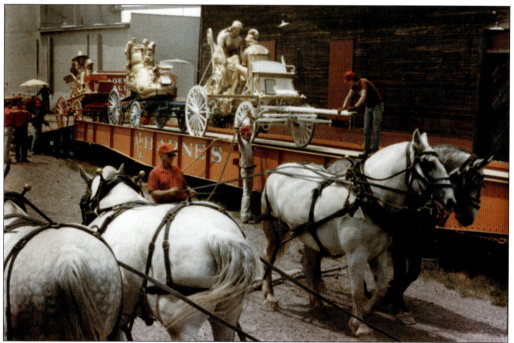

Normally, one wagon was loaded at a time, but this photograph shows an exception. The fairy tale tableau wagons were very light and always loaded together in the same order. Once the pull-up team had all three on the flats, it unhooked. The pull-along team, seen in the bottom left corner, hooks up and pulls the Cinderella, Old Woman in the Shoe, and Mother Goose tableaux down the line.

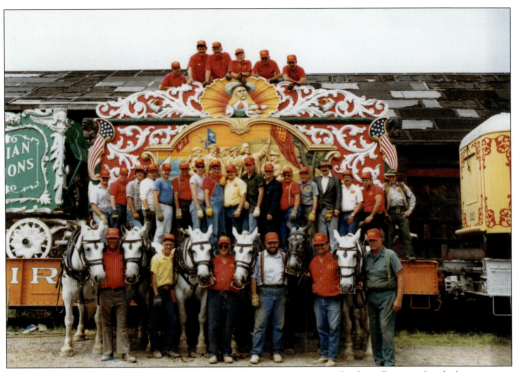

Once the last flat was loaded in Baraboo, the entire train crew and horse teams paused for a group shot. Posing in front of the 1903 Pawnee Bill bandwagon No. 80, the 29 crew members are justly proud of authentically re-creating circus wagon loading safely.

At the end of a long day of loading, the sun sets over Circus World Museum. The train was loaded and would head out the next morning. It was a two-day trip to Milwaukee, with many stops along the way. The train crew was packing for the second leg of its journey.

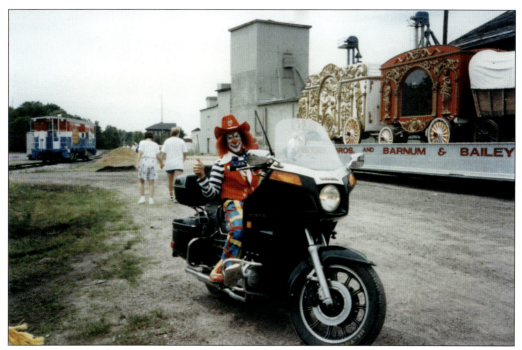

Everyone who worked at Circus World came to see the train during loading. The Circus World clown, Mr. Bill (Bill Machtel) stops by on his Harley motorcycle and gives his thumbs-up approval. Behind Mr. Bill is the caboose. Several train crew members rode in the caboose. At scheduled stops, the caboose crew checks that all chock blocks are tight.

The morning of departure, the Circus World concert bandleader, Richard "Rick" Percy, brought the entire band in costume to the coach loading spot. It serenaded the gathering group, playing only authentic circus music. The band lifted the spirits of everyone—those staying behind and those riding the train.

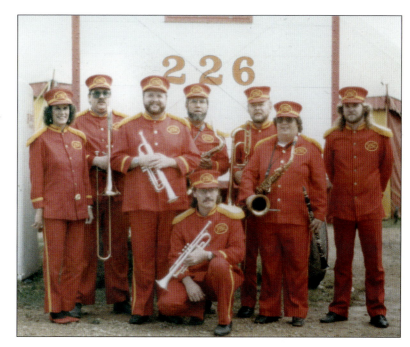

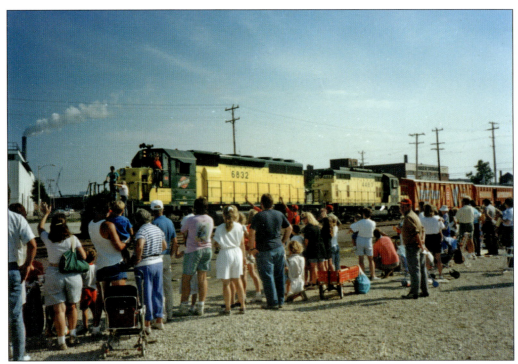

The circus train pulls into Milwaukee in the late afternoon. Crowds of people line the tracks on both sides to catch a glimpse of circus history brought to life. The train slowly moves to the unloading spot, where the first off the train are the people in the coach cars and the horses.

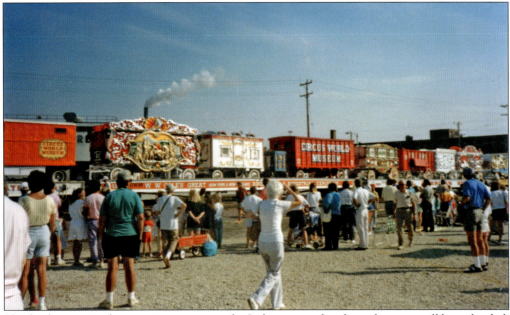

Slowly, the spectacular wagons arrive onto the Italian grounds, where the train will be unloaded. Wagons lengths were carefully measured and positioned on flatcars in a particular order for unloading. The first units off usually were the Caterpillar tractors and Mack truck, so the machinery could move the wagons once they came down the runs.

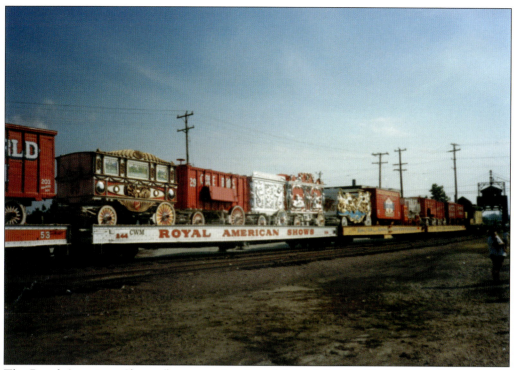

The Royal American Shows flatcar carries, from left to right, the Orchestmelochor wagon, a wardrobe wagon with the work tables attached on the outside; the Sparks Circus tableau; and the Hagenbeck-Wallace Lion's Bride tableau. Behind the train to the far right is a rotating bridge, which remains parallel to the shore for easy boat traffic out into Lake Michigan today. It used to pivot 90 degrees to span the Milwaukee River for train traffic.

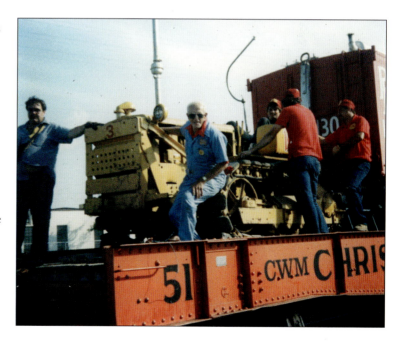

The unloaded coaches are moved to a siding as another switch engine guides the first string of flatcars to the unloading spot. On the left of the flat is Norm Anderson, a railroad worker who communicates with the engineer at the back of the string of flatcars. Mel Fischer, in blue, makes sure the Caterpillar starts up. Once the runs were set (as seen on page 16), the Caterpillar would pull off wagon No. 30, starting the unloading.

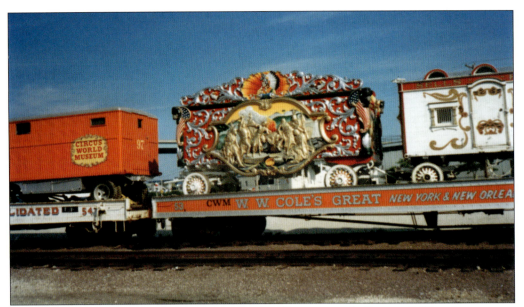

Ready for unloading are the Circus World Museum office wagon, the Pawnee Bill bandwagon, and the Sells-Floto ticket wagon. Of these three wagons, only the Pawnee Bill bandwagon was paraded. The office wagon provided office space for the Circus World Museum staff, and the Sells-Floto ticket wagon was used to sell tickets to the circus performances held on the staging grounds.

As the shadows lengthened, the hook roper, Steven Mader, keeps the pull rope clear as the horse team pulls the wagon down the flats. One string of six cars could be unloaded before darkness. The train engine then switched out the empty flats and brought the next cut in for unloading the next morning.

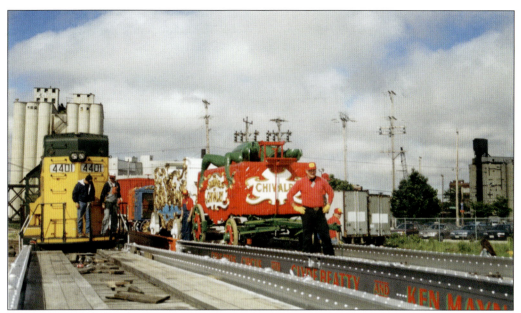

Empty flats roll behind engine No. 4401 as wagons are unloaded from the adjoining track. Only the body of the dragon on the Golden Age of Chivalry wagon is visible. The two heads, wings, and tail are safely stored inside the wagon body because of constant vibration while traveling.

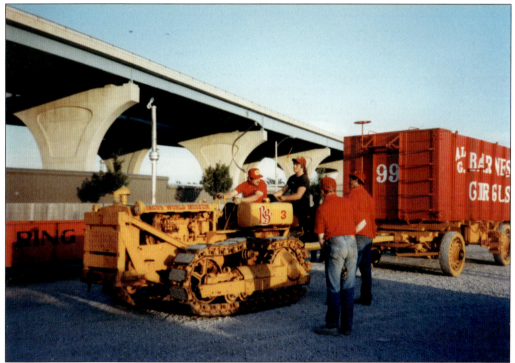

Caterpillar tractor driver Timothy "Tim" Perkins (left) and pinner Christopher "Chris" Peterson (second from left) pause to get orders from Harold "Heavy" Burdick (right). The man with his back to the camera is unidentified. The flats are all unloaded, and the train crew collects all the chock blocks into wagon No. 99. The blocks were needed for the return trip to Baraboo.

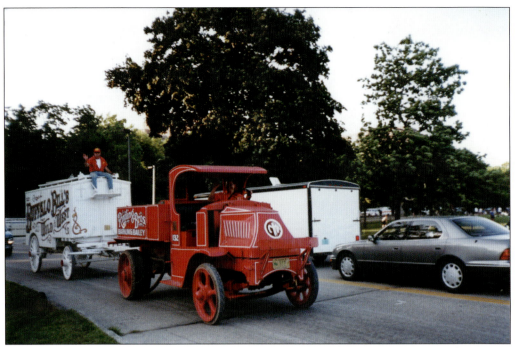

The red Mack truck pulls the Buffalo Bill ticket wagon to the staging grounds; it is the last wagon of the evening. In 2009, the unloading moved from the Italian grounds to the Wisconsin Southern Railroad yard. It was a four-mile trip to the show grounds. The last leg of the trip included a steep hill, and the rider on top of the wagon operated the wagon brakes.

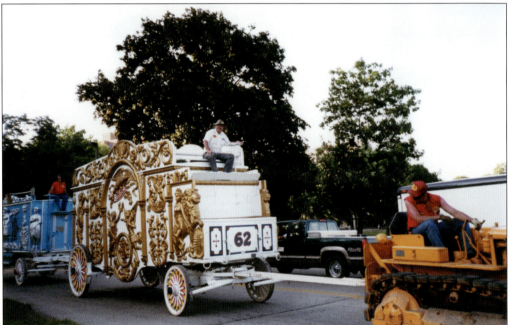

The first group of unloaded the wagons was hitched together to caravan over to the staging grounds. The Caterpillar tractor driver pulls the Columbia bandwagon No. 62, which in turn pulls Beauty tableau No. 89. Train crew members ride on top to operate the wagon brakes if needed.

Two
Parade Grounds

Caterpillar tractor driver Tim Perkins checks clearance on the wagon he is pulling. Under No. 11, one can see the hookup arrangement for pulling the wagon. With the long pin, the driver could hook up to any wagon pole and keep it level so it would not break or twist.

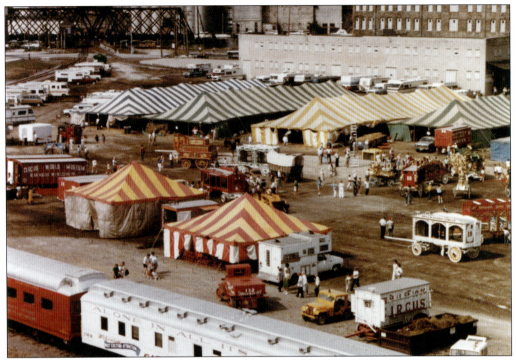

In 1985, the parade returned to Milwaukee and was staged at the Italian grounds, a compact lot. In the foreground are the coach cars. The large striped tents were for the draft horses, with their semitrailers parked behind them. In the upper left of the photograph is the campground for the teamsters' families. The wagons are parked up and down the midway.

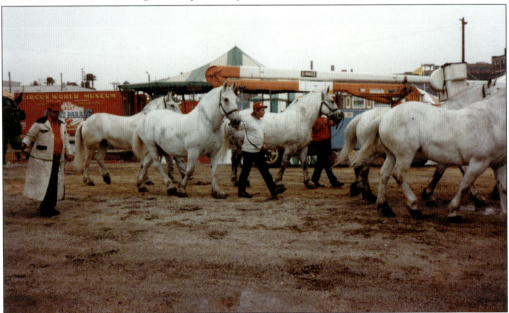

In 1990, all teamsters were asked to voluntarily bring their horses to the center midway for a large group picture. The six Circus World Museum white draft horses joined a group of approximately 360 Belgians, Percherons, Clydesdales, and various pony breeds.

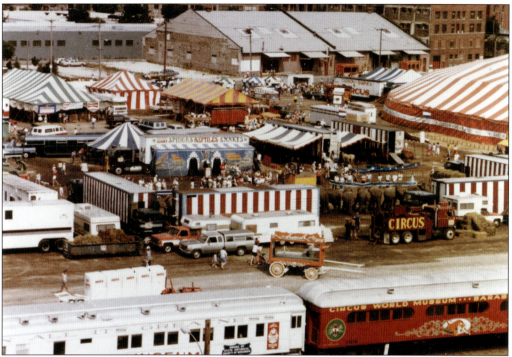

This view, looking north on the parade grounds, shows the corner of the Carson & Barnes Circus tent in the top right. In the middle of the image, the red-and-white-striped semitrailers create a fence that keeps visitors out of the backyard. A fire lane is open between the animal trucks and the coach cars on the siding.

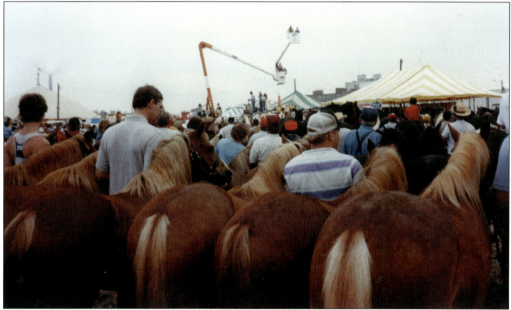

Horses in this group picture range from large draft horses down to ponies. In the center are two large cherry picker booms. The photographers are in the buckets, capturing the large assembly of horses and teamsters.

The train engine finished spotting the loaded flatcars. The assigned Caterpillar driver jumped up on the flat to start the main motor up and let the oil circulate. The tractor is positioned on this flat to pull the green generator wagon off. That generator provides electrical power for the families that camp on the grounds.

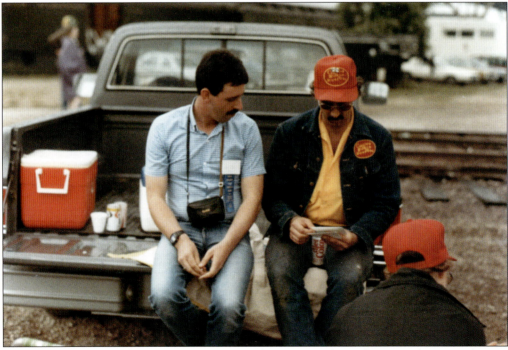

Circus fans, model builders, the Circus Historical Society, and Windjammers (musicians) came from all over the world for the parade. When the train crew got a break, everyone was "cutting up jackpots," or telling circus stories. Stephen "Steve" Flint (right), from Janesville, Wisconsin, looks at pictures with Wayne Cordell from Ulverstone, Tasmania, Australia.

In 1995, the parade grounds moved to Veterans Park on Lake Michigan. An advance crew came in, marked out the lot layout, and buried phone and electrical wires. David Saloutos (pictured) oversees the process. Until the office tent was erected, phone calls came in to the rotary phone on his lap.

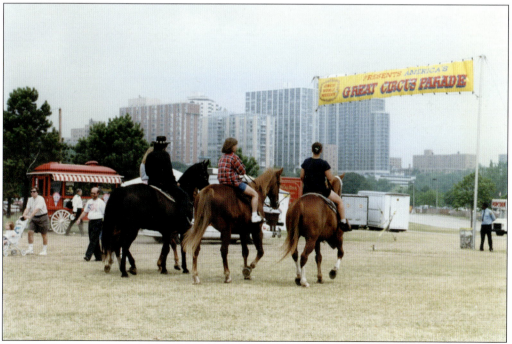

Entrance banners were put up on both ends of the midway. While the banner was on the ground, cables were strung through the top and bottom of the banner. It was then connected to the poles. It was not unusual to see horses out for an evening stroll.

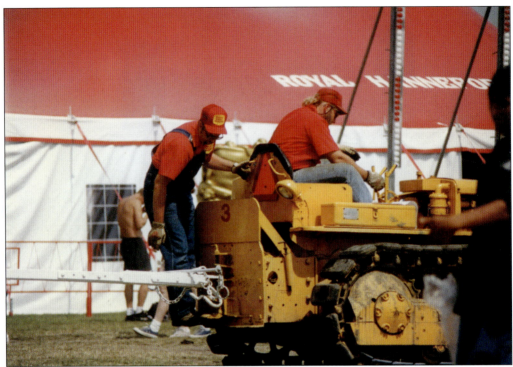

Wagons were constantly moved. The Caterpillar driver, Verlin Hill, depended on his partner, referred to as the pinner, when backing up for both hooking up and unhooking. The pinner, hanging on to the back, straddles the pole while moving straight. When it is time to disconnect the wagon, the pinner moves to one side, grabs the pin, and pulls it straight up to disconnect.

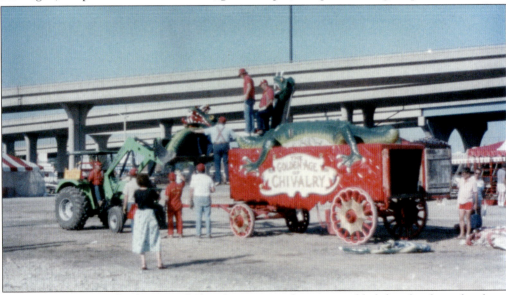

On the Italian grounds, the Age of Chivalry wagon is being assembled shortly after it has been unloaded. One dragon head is in place, and the other is in the tractor bucket being raised to the wagon top. One man rides up in the bucket, bracing the head, while the other two men on the wagon wrestle it into place. A wing lies on the ground, waiting for assembly.

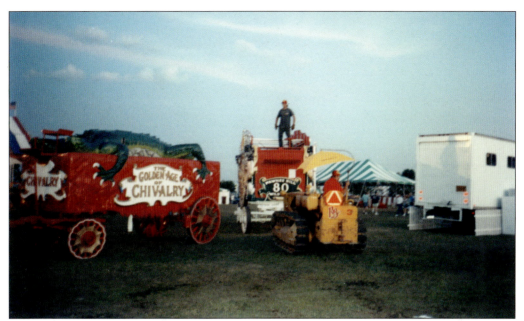

Wagons are positioned on the parade grounds after arrival from the train yard. Tim Perkins backs up his Caterpillar, which is pulling wagon No. 80, the Pawnee Bill, to its assigned spot. The Golden Age of Chivalry will be placed next and then assembled. It never traveled with its dragon heads, tail, or wings attached; all those features were stored in the interior of the wagon.

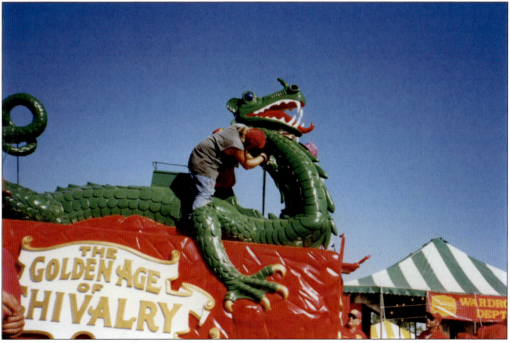

Train crew member Randy Peterson tightens the dragon heads at the front of the wagon. The tail is in place, and the last two pieces to attach and assemble are the wings. The crew affectionately referred to this wagon as "Puff." This wagon was built for parading from inception. Once the five removable pieces are stored inside, there is no room for other circus gear.

The train traveled for two days throughout the state before it arrived in Milwaukee. When the train pulled out of Baraboo, the train crew drove down and went to work preparing the grounds. Some of its duties included unloading a semi full of A-frames and chains as well as semis with hay and straw, and putting up non-horse tents. The A-frames and chains were used for horse tie-offs in the horse tents. In the photograph above, crewmen lay out the office tent. The top was made up of four sections that were laced together before the tent was raised. The crew starts with the end pole and works its way down the tent to raise the four main poles, as seen below.

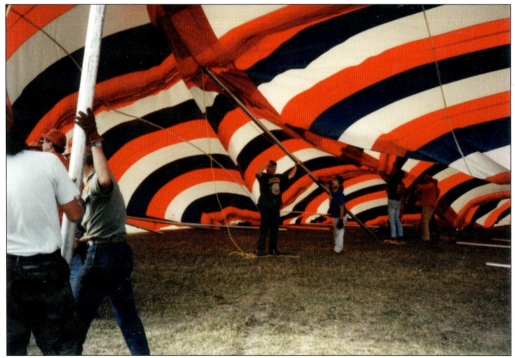

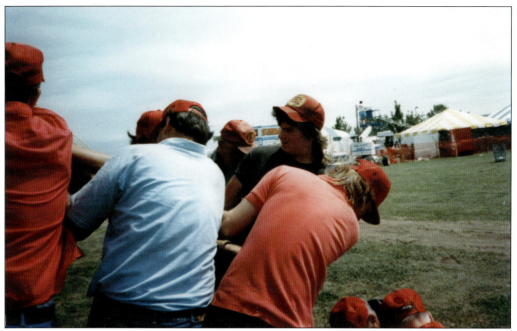

The tent top is in the air, and the crew works to tighten down the side guylines. Working down one side and then up the other took team effort to pull the rope tight enough for it to be staked firmly in the ground. Breezes off the lake, while cooling for the crew, require extra strength from the team to anchor the tent securely.

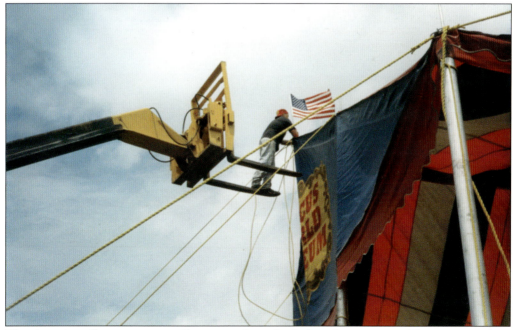

The American flags were normally put on the poles before they went up. The crew members forgot to put the end pole flag on before they raised it one year. Due to the pole height, a front-end loader is needed to lift a crewman up to secure the flag. There were often strong breezes off the lake, and the flag was flying high this day.

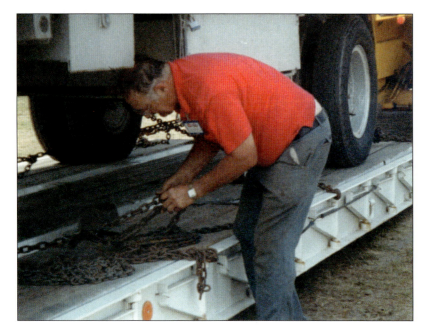

In later years, as the parade grew, not all circus wagons traveled by train. Ned Kronberg loosens and removes the chains from this rubber-tire circus wagon. It was driven down from Baraboo, Wisconsin, on a flatbed trailer truck.

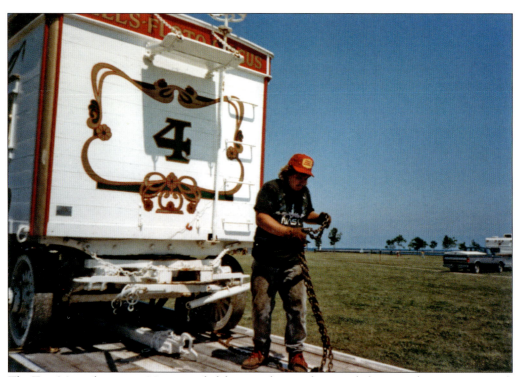

The Tom Mix ticket wagon No. 4 traveled down to the parade grounds from Baraboo on a semitruck flatbed. Heavy chains and binders crisscross over the front and rear axles. Once the chains were removed, the wagon pole, under the center of the wagon, was inserted into the wagon. The pole was pinned in place and used for maneuvering the wagon as it was pulled off the truck.

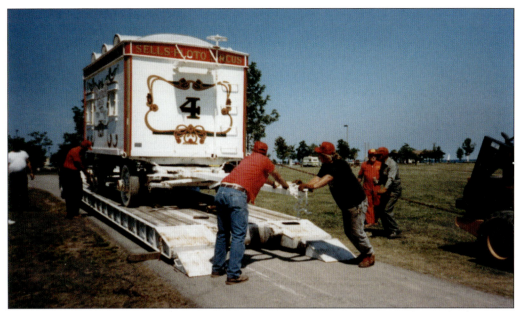

A tractor with a chain hooked to wagon No. 4 slowly pulls the wagon forward for unloading. The polers each push on the pole to keep the wagon straight as it moves forward down the ramps. At the back left wheel, there is a chocker walking along, ready to stop the forward momentum if the polers have difficulties.

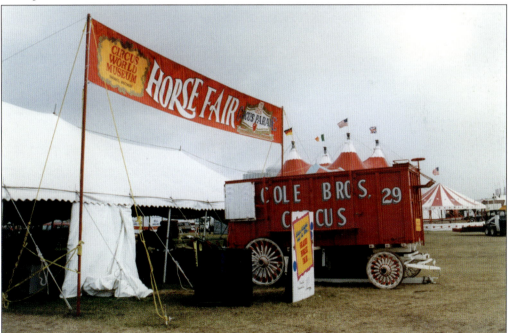

In 1997, a horse fair tent was featured. Visitors to the parade grounds could see, pet, and learn about all different horse breeds. From the small mini-ponies and horses to the large draft breeds, these horse ambassadors represent the over 700 horses that made the parade possible. Cole Bros. Circus wagon No. 29 was traditionally part of wardrobe; in it, the sidesaddles, horse blankets, and various decorative horse head pieces traveled.

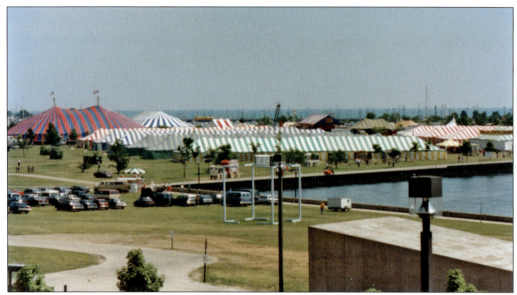

This is a partial view of the parade grounds at Veterans Park. The darker blue background at treetops and tent line is Lake Michigan. The red and blue top was a circus tent, positioned halfway up the grounds. The white and green or red tops were for the draft horses and smaller pulling teams.

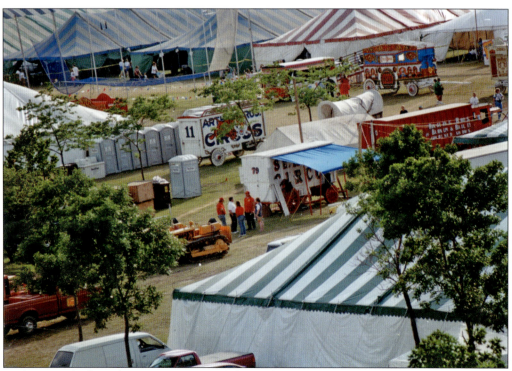

In this view, looking down on a portion of the midway, wagon No. 79, with the blue awning, is the shop wagon. It was the train crew office for the run of the parade. Spotted on the midway are various parade wagons. Behind the shop wagon are the latrines, or donikers, as they are referred to by circus folks.

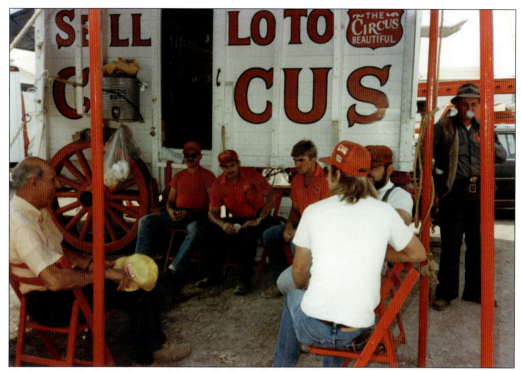

Herbert "Herbie" Head, seated left with the yellow hat, visits with train crew members. Inside the wagon front are drawers filled with nuts, bolts, and washers in any size that might be needed. Several of the train crew members were welders, and the wagon carried hoods, gloves, and gas tanks chained to the inside. Woodworking tools, saws, files, hammers, clamps, and more were also carried inside.

The back of the shop wagon opened up the opposite of the way most wagons do. Rather than opening like doors to the right and left, it was split in the middle horizontally to open up and down. This created a work table and easy access to the large, heavy repair equipment. William "Bill" Dexter snatches the hat of a resting unidentified crew member. Crew pranks were a tradition.

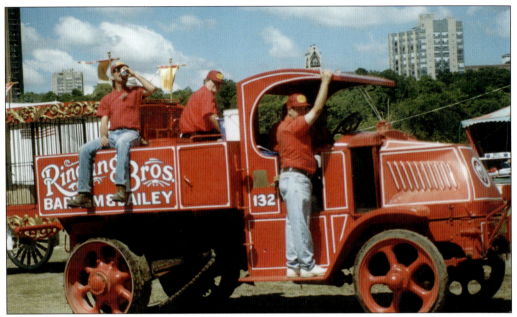

After the grounds were set up and the train was unloaded, train crew members had various duties. Being part of the Mack team was always popular. As more and more horses arrived, the Mack was kept busy filling water tanks for the animals. Many trips a day were made to a main city hydrant for water that was then delivered to the horses, circus animals, and petting zoo animals.

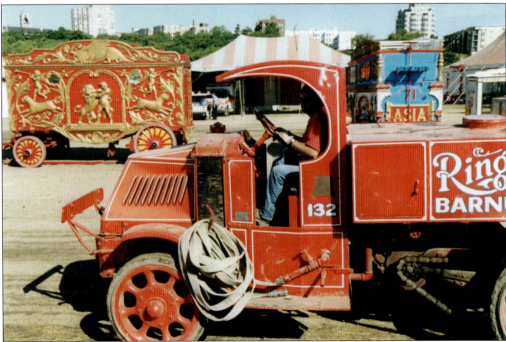

The tank on the rear of the red Mack truck No. 132 was filled multiple times a day. On each end of the 120-foot-long horse tents were two heavy water tanks for horses. While the truck could not get in close, the hose it carried stretched from the truck to the tanks. This chain-driven truck, with solid rubber tires, was hand started with a crank on the front.

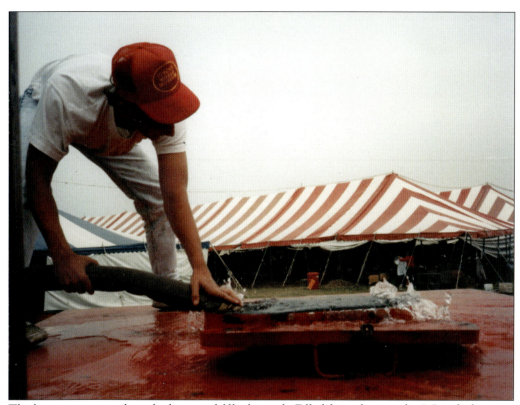

The hose is connected to a hydrant and fills the tank. Filled from the top, the 2.5-inch-diameter hose was held in place by the top crewman. After the tank was filled, the top crewman would call down to "shut her off." With the tank full, the water started to spill out as the workman at the hydrant pranked the crewman known as the "hose guy."

One of the stops the red Mack truck made was to fill Hippo Den No. 28. Mark Pulkownik fills the water tank while Rebecca "Becky" Burdick watches. The hippo's name was Petunia. While refilling her tank daily, Mark sang, "I'm a lonely little petunia in an onion patch."

The wardrobe tent is being set up. The two wagons on the right are in place, and their contents are being unloaded. A semi and a small changing tent block off the back open end. On the left, not in the picture, would be more wardrobe wagons when unloaded from the train. The sidewall poles for this tent are much taller than other tents to accommodate the wagon height.

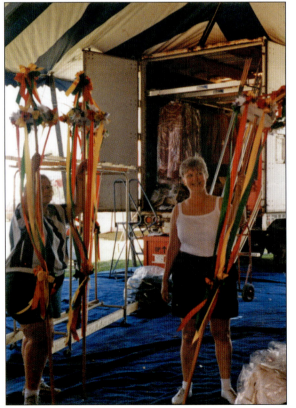

The semitrailer is in place, the blue carpeting has been laid, and the Cossack Band Color Guard Maypoles have been brought out by Linda Nyholm (right) and an unidentified assistant. The entire wardrobe tent was carpeted to protect the costumes. Circus World provided parade section band costumes, in keeping with the section theme.

The wooden steps are pulled out of the wagon and the unloading of the wardrobe tent has begun. On the left are the Raggedy Ann color guard costumes. These costumes were part of the clown band costumes that the Baraboo High School marching band traditionally wore. They had the proud honor of marching in every circus parade.

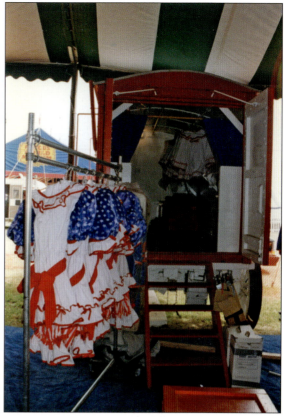

The wardrobe department is fully set up, and the area was fenced off. As the teamsters arrived, they went to the wagon on the right and picked up their "reds." Teamsters, out walkers, and riders all wore the same red costumes. Teamsters were identified by their white pith helmets, and out walkers and riders had red hats. To the far left is the office tent.

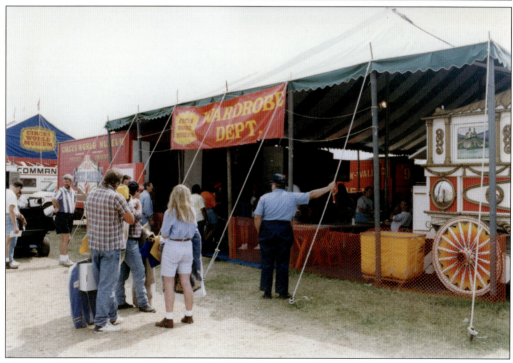

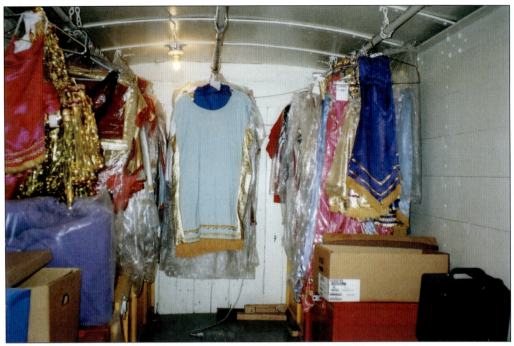

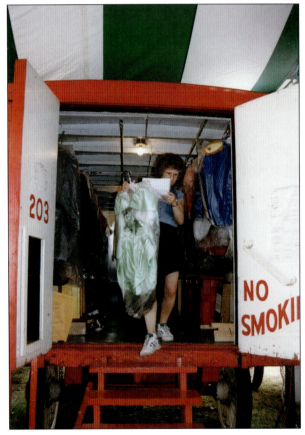

Pictured here is the interior of a wardrobe wagon; the red crates and boxes along the walls carry all miscellaneous costume pieces. Each wagon had a type of costume based on parade section assignment. The heavy pipe racks hold the hanging costumes. When the wagon was packed up, wooden sticks were laid across the top of the hangers and tied down, which kept the costumes from rocking off when the wagon was in motion.

To retrieve a costume from the wardrobe department, the parade participant had to turn in his or her official letter. The letter told the wardrobe volunteer the name of the participant, the costume, parade section, and wardrobe wagon number. The wardrobe department kept all letters so that it could account for and chase down any unreturned items.

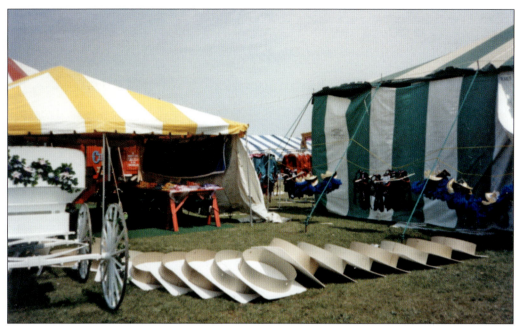

Several of the horse-riding units had large floppy colorful hats. For storage and travel, they were placed on these cardboard forms for protection when packing. As the hats were handed out to the participants, the forms were set out to air in the bright sunlight.

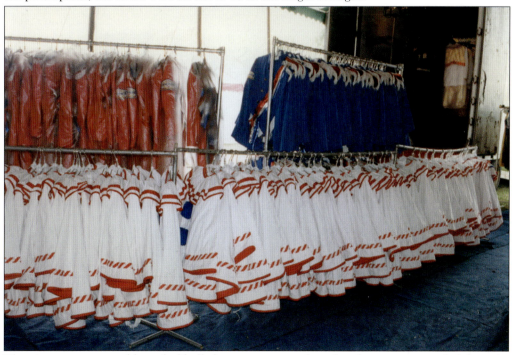

The circus wagons could not hold all the costumes, so these band costumes traveled down by truck. The white costumes in the front were for the clown band, fitted to the kids of Baraboo who played in the high school marching bands. The red and blue band uniforms in the background were for the bands playing on top of bandwagons.

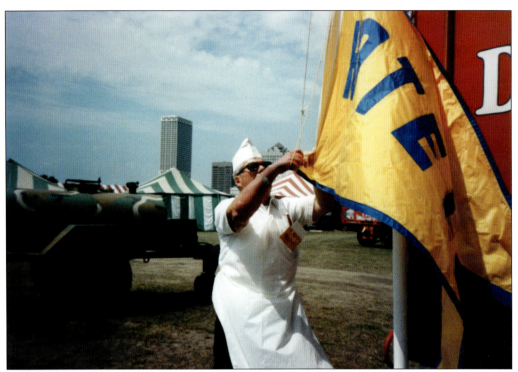

A circus tradition was followed on the grounds: the cookhouse was not open until the flag was raised. Gary Davidson, a cookhouse crew leader, hoisted the flag to announce the food was ready. The cookhouse served hearty breakfasts, lunches, and dinners for all participants who were issued a cookhouse pass, which was checked and punched at every meal.

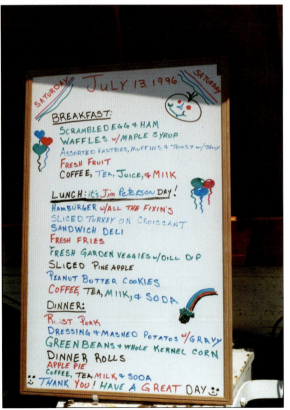

Over the years, the number of meals prepared increased from just feeding the train crew to feeding a multitude of weekend volunteers. The cookhouse crew got creative and started posting the menu outside the tent. There was always a good variety of fresh fruit and veggies for salads and snacks.

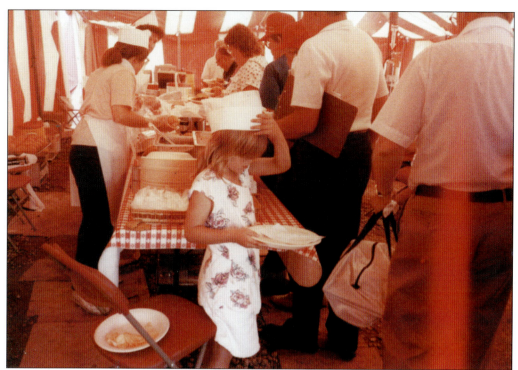

After a volunteer's card was punched, he or she got in line for a meal. Staples were served first, with beverages, coffee, and desert at the end of the line. Many volunteers worked 12-to-14-hour shifts and could not leave the grounds to purchase meals. Besides providing wholesome food, the cookhouse provided a great meeting spot to catch up with old friends.

The move to Veterans Park provided additional space, which allowed room for the dining department wagon No. 223. In the early years, almost all food fed to the train crew and a few miscellaneous volunteers was prepared in this wagon. The head chef, Harold "Harry" Saloutos, was responsible for planning and providing the meals. He stands in this picture with his No. 1 assistant, his son David "Dave" Saloutos.

Train crew members were on call for various duties the entire run of the parade. Each year, Edward "Ed" Pope (standing) and an unidentified volunteer washed wagon wheels the Saturday before the parade. The wagons would pick up a lot of dust and dirt while being transported to Milwaukee. The fancy turned spokes were cleaned, and they sparkled under Ed's meticulous care.

Walter "Walt" Heist was normally the red Mack driver. Here, he has been pulled into costume duty, helping the sway pole artist. It was a tough job, but he had to hang on to the performer's fancy outer costume while she climbed the ladder to the top of the sway pole. Free acts were common on the parade grounds.

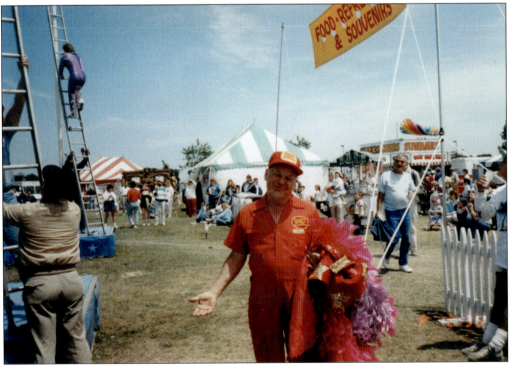

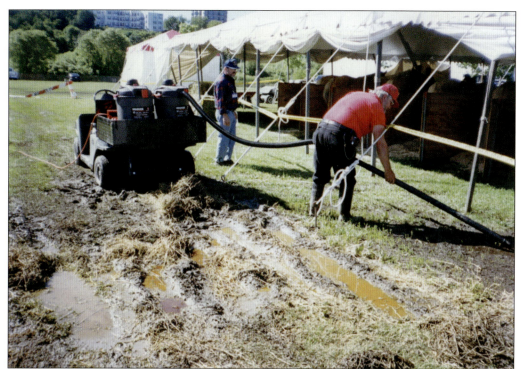

As demonstrated here, another unusual train crew assignment happened because of heavy rains. Drainage was not the best on the grounds, and without heavy winds, it took quite a while for puddles to dry up. A train crew member sucks up the water with two wet-dry vacuums. Each unit held approximately 20 gallons, and many trips were made to remove the standing water around the tents.

Train crew members were not the only ones who tackled unusual tasks on the parade grounds. Circus World had some very dedicated, longtime volunteers. John Vick of Baraboo, Wisconsin, was one of those exceptional volunteers, helping in any area when asked. He wears a purple balloon crown and delivers two armfuls to a vendor.

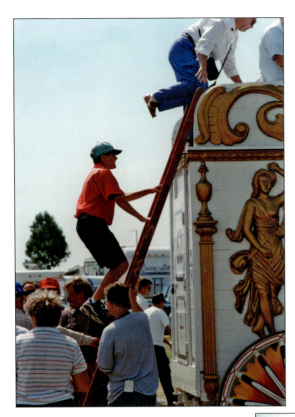

Saturday before the parade was the time for every teamster to take his assigned wagon for a practice run. This was a shakedown trip to make sure the wagon was functioning properly. It was also a time for the teamsters to give their families a scenic ride. The only way to get up on top of the wagon was by ladder. This is the Columbia bandwagon being loaded.

For practice runs, every team was assigned a set time to avoid traffic jams. Richard "Dick" Koltz and his family hitch their eight-up Percheron team up for practice. Dick holds the lines while his daughters and sons hitch up the team. He drives the Great Britain bandwagon No. 100. All the ladders used to put people up on the bandwagons and other wagons were stored in this wagon.

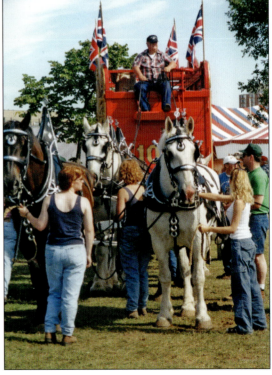

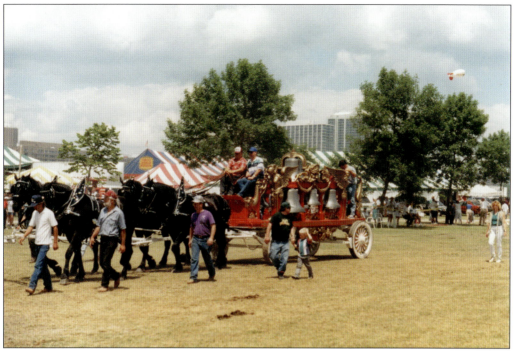

The Ringling Bell wagon was a popular parade favorite. There was an out walker with each horse as it made a practice run. This wagon was built for the 1890 circus season in Baraboo, Wisconsin, and had nine huge bells that were cast by the Centennial Bell Foundry in Milwaukee.

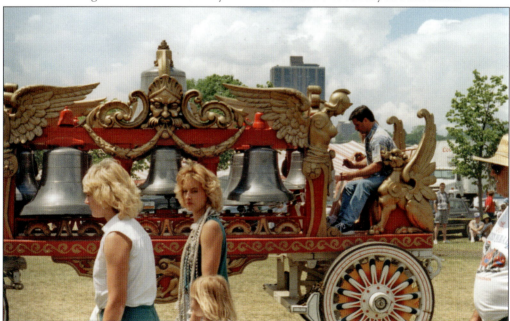

When the teamster gave a signal, David Saloutos started playing a song. This was to prepare the horses for parade day. Music was made when Saloutos, sitting on the backseat, pulled one of the spring-primed levers. The bells played the white notes from a piano keyboard; there were no sharps or flats. And the standing joke was that the wagon was always in tune.

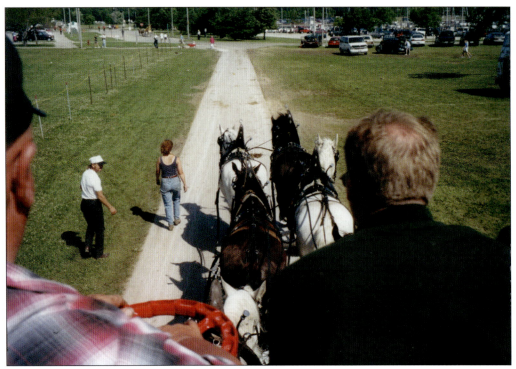

This view was captured from right behind the teamster on top of the Great Britain bandwagon. Though only four horses are visible, this is an eight-up team, hitched in a checkerboard pattern. On this practice run, Matthew "Matt" Koltz drives while his father, Dick, is the brakeman. The wheel would be turned, which pushed the brake pads against the rear wheels for stopping.

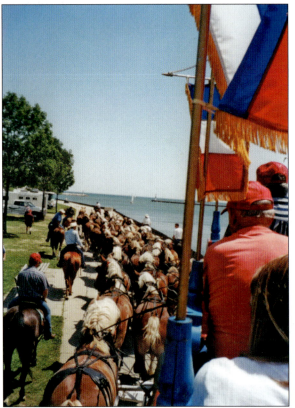

This perspective was taken from the top back of the Two Hemispheres bandwagon. It was pulled by 40 horses, and one could barely see the lead team at the lead. There were four outriders on each side of the team. The four-wheeler horses hitched to the wagon did most of the pulling. While it looks massive, it is a light bandwagon. Paul Sparrow, following in the footsteps of his father, Dick, drove the team.

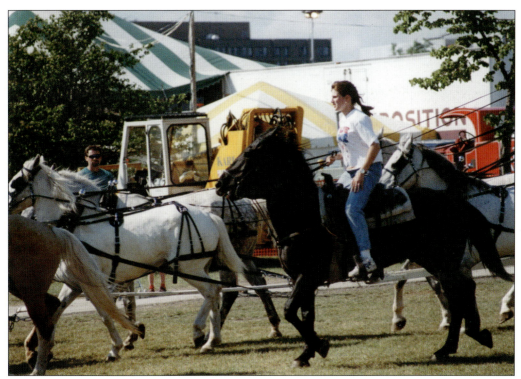

Outrider duties included keeping the team horses calm in the new environment. They also provided extra hands if a harness, line, or wagon pole broke down. Robin Peterson rides alongside a horse hitch as it makes its practice run.

Dennis Stork (far right) and his crew were outriders for every team's practice run, keeping curious visitors out of harm's way. On parade day, their walk-over horses were stationed on the two main river bridges on the route. The bridges had open grids, which many horses did not want to cross. The walk-over horses would just get ahead of the hitch lead team and walk across. They did the same thing for the riding units.

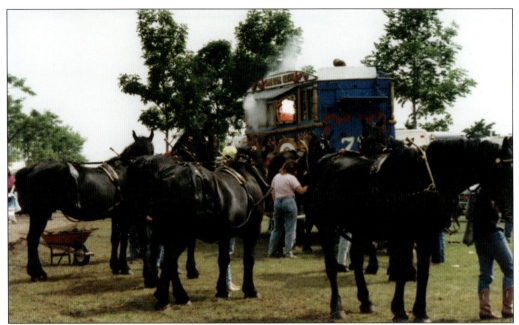

William "Bill" Farmer's team of eight black Percherons always pulled the Cole Bros. America wagon. It had a steam calliope inside with loud shrill whistles that played along the parade route. In this picture, the calliope plays and the horses have been brought over to hear it. This conditioning prepared them for the noise behind them in the parade. Filled with water for steam, this was the heaviest wagon any hitch pulled.

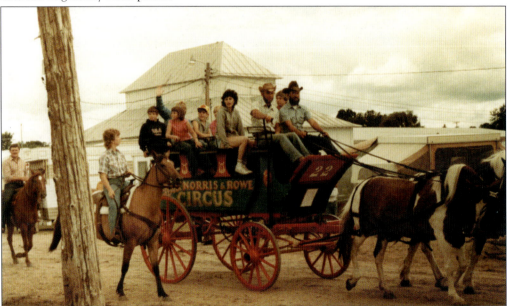

When the parade was brought back to life in 1980, it was staged at the Sauk County Fairgrounds and paraded through downtown Baraboo. Kenneth "Ken" Koester gives the family a ride on the Saturday practice run. Koester was the only teamster who pulled a wagon in every parade from the Schlitz days to the present, spanning from 1963 to 1972, 1980 to 2009, and 2013 to 2015, during the Baraboo community parades.

Teamster meetings were held on Saturday after all practice runs were finished. Robert "Bob" Parkinson stands on the wardrobe wagon to advise teamsters of any route issues, review hand signals the parade marshals use, and answer any questions the teamsters have.

Chappie Fox, donning his trademark fedora and bow tie, is being interviewed by a reporter after the practice runs. It was Chappie's dream to re-create an old-fashioned circus parade, and with help from friends and circus fans, his dream became a reality.

Saturday was the busiest time on the parade grounds. In addition to all the practice runs on the back lot, many people came to see and learn about the beautiful wagons. John Lloyd, a Circus World Museum director, is dressed in a period costume while leading a wagon tour.

Saturday evening, the back lot entertainment consisted of teamster shovel races. Two riders with long ropes and heavy duty shovels would take on any volunteer riders. The teamsters' goal was to unseat the shovel rider on the back turn with a big whiplash turnaround. The challenge for the rider was to stay seated with his or her feet up off the ground. The horses gallop with men riders and trot with lady riders.

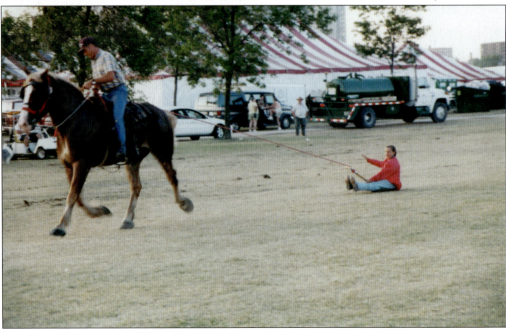

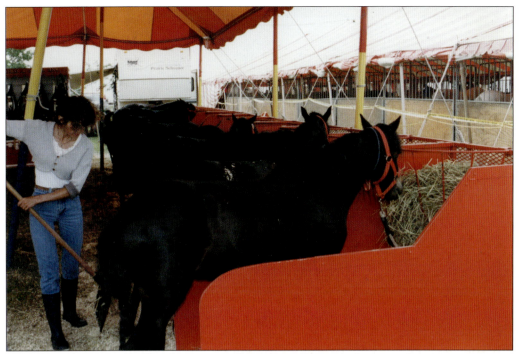

This team of ponies arrived with its own stalls and tent. Keeping the tents clean was an ongoing job. Large dumpsters with wooden ramps were located behind the horse tents in several areas on both sides of the parade grounds. The wooden ramps allowed the teamsters to wheel their loads to the front of the dumpster.

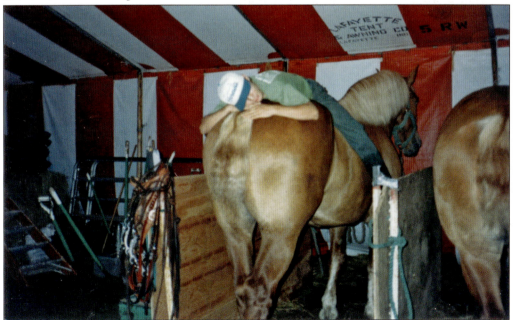

The McCrossan Boy's Ranch of South Dakota had a team of Belgians that pulled for several parades. Each horse on the team had an assigned caretaker. This young man, tired after a long day, rests on the back of his charge.

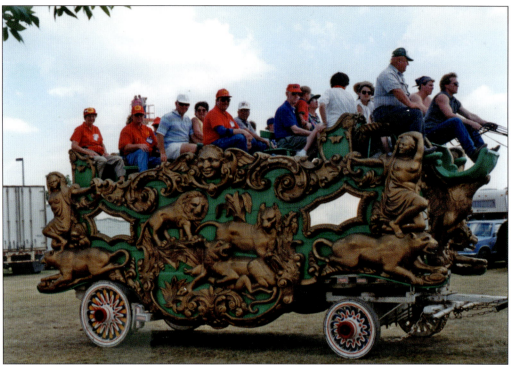

The Lion and Mirror bandwagon went through several changes over the years. In the early 1960s, it was painted white with gold wood carvings. By the late 1980s, it was painted green with gold wood carvings. In 2000, it was not only repainted red, but all the wood carvings were gilded. The wheels were changed for the latest upgrade, and as an additional bonus for the wagon's new look, all-new band uniforms were created.

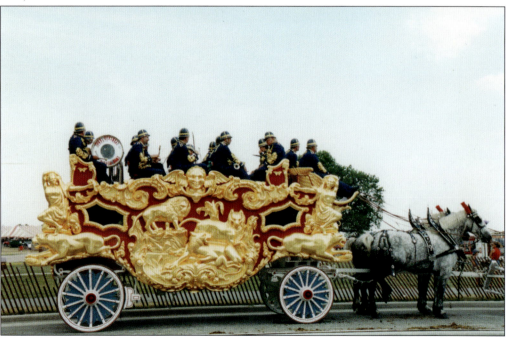

Three

PARADE DAY

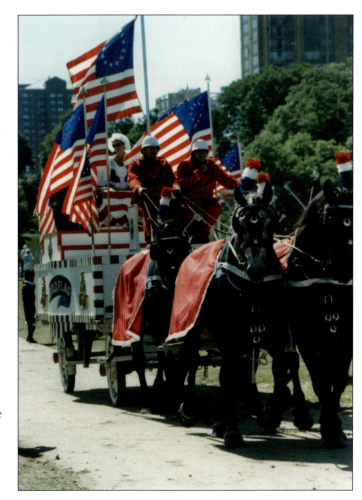

A powerful team of Percherons pull It's a Grand Old Flag wagon No. 70 in the America section of the parade. Betsy Ross sits with a flag over her lap. In addition to the large flag directly behind her, there are six other American flags on this wagon. The horse's red, white, and blue plumes and horse blankets add to the colorful display.

The flag and banner volunteer crew was up early on parade day. By 7:00 a.m., the wagons were moved all over the grounds and onto the street for hitching positions. Members of this crew caught the United States bandwagon, pictured behind them, and got the flags on all four corners just before the wagon was pulled off the grounds. The pickup truck carried all banners, flags, and some of the crew.

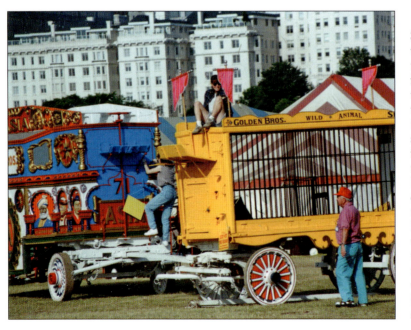

Some of the first wagons to get their banners or flags were the cage wagons. Animals were loaded early in the morning, and putting the flags up before the animals were loaded was easier on the crew and the animals. Behind the cage wagon, another volunteer climbs up the Asia wagon to deck it out with its assigned banners.

The volunteer was placing the English flags on the "John Bull," or Great Britain wagon No. 100. Specific flags or banners were assigned to each wagon. Since this was one of the tallest wagons on the grounds, the volunteer could aid the ground crew by calling out what wagons were down the line or headed off the grounds.

The America Steam Calliope did not have a solid roof; there were only cross beams to allow air and steam flow for the boiler inside. The volunteer carefully steps from beam to beam after placing the back flags. Synthetic material could melt from extreme heat, so the flags for this wagon were made of cotton.

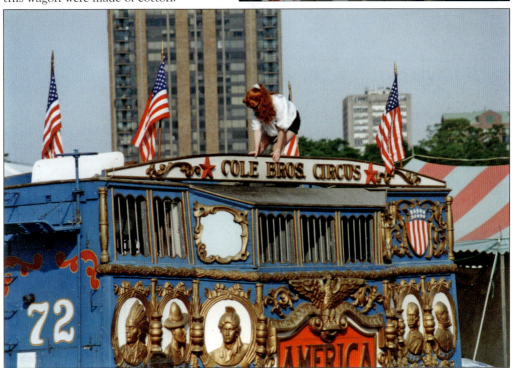

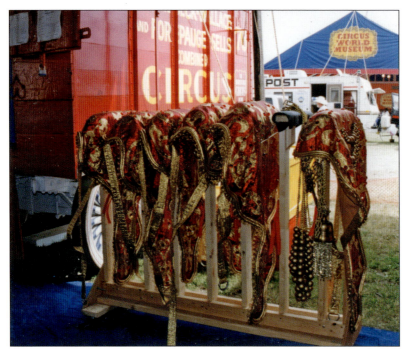

In the wardrobe department, before all the participants started arriving, the animal costumes were set out. This rack of elephant headpieces was then moved to the elephant area. There was another rack of blankets that covered the elephants. All costumes went on shortly before the elephants were scheduled to step off.

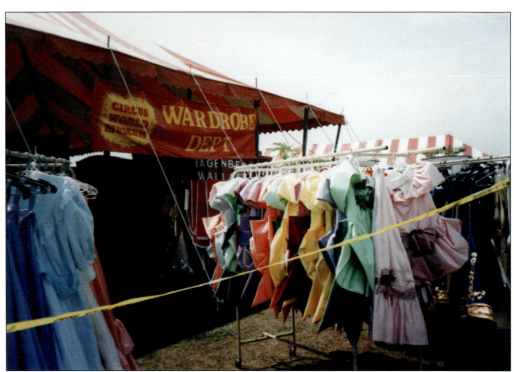

Costumes for the riding-horse units have also been moved out of wardrobe to an area set up for horse pickup and costuming. Hanging on the rack to the right are the Rainbow Equestrian costumes. Another rack of matching skirts was added once the costumed rider was seated on her horse.

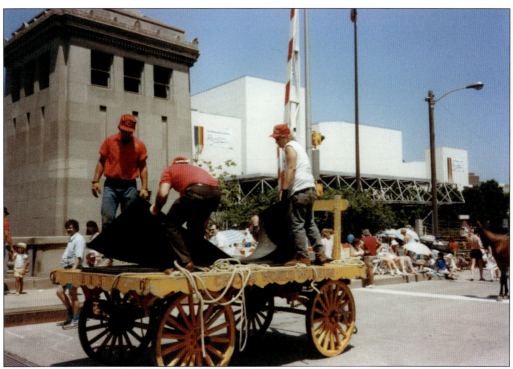

The two bridges with open-grid decks on the parade route crossed over the Milwaukee River. Horses would not willingly cross over an open-grid bridge fairly high over the water. To solve this issue, a Caterpillar tractor towed two wagons loaded with rubber mats and the crews to bridges, with the larger wagon hooked to the tractor and the smaller wagon hooked at the end. The tractor would drive the route, dropping off the smaller wagon before taking the second crew on to the larger bridge. The crew unloaded the mats and laid each in a herringbone pattern over one the side of the bridge. Heavy wagons crossing the bridge would often shift the mats, and the crew would reset them many times over during the parade.

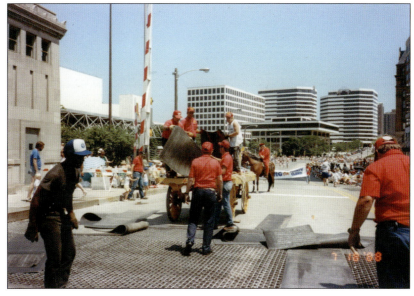

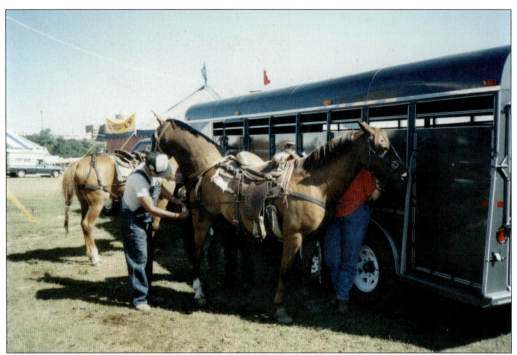

A popular parade attraction for the kids was the two-headed horse. Horse heads were made with the same coloring as the riding horse. Prior to parade time, the second lightweight head was fitted onto the back of the real horse. This horse stands patiently while the second head is strapped on.

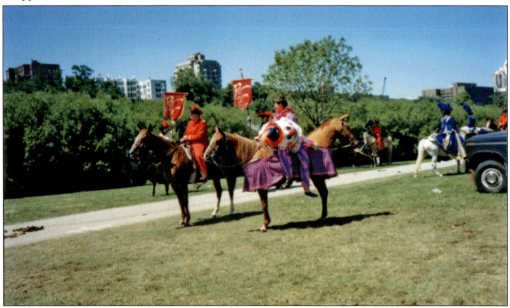

Waiting for the cue for step off, the rider of the two-headed horse holds the headpiece he will wear. The headpiece had two faces, one facing in each direction. The real rider's feet were under the skirt facing forward. A second set of legs was attached to the rear-facing clown to complete the illusion of two riders on one horse going in both directions.

Inside one of the horse tents, family members polish the harness and bridles for their team. The horses were brushed, and hoofs were polished. Teamsters were rightfully proud of their teams and enjoyed showing them off in a noncompetitive setting. Most draft horse teamsters at county and state fairs competed with only their specific breed, so having all the breeds represented at one venue was unique.

The Abbot-Downing Concord Stagecoach from the Circus World collection was featured in the Wild West section of the parade. The body of the coach rests on leather straps fastened to the front and rear chassis. This setup made the body of the coach rock when in motion.

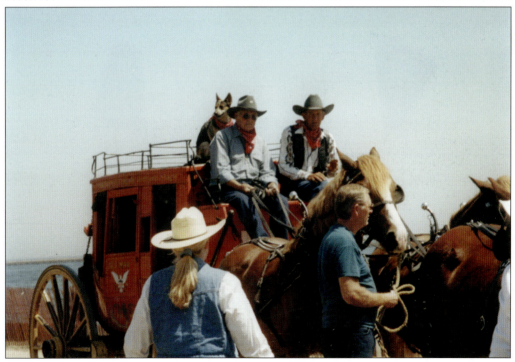

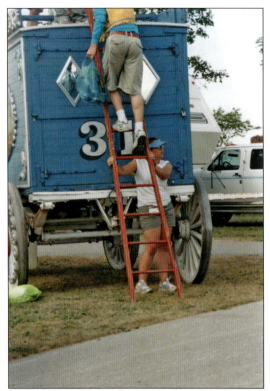

The wagons have footholds on the front so the teamster and brakeman could climb up. The other passengers on the wagons climbed up by ladder. Ladder duty was part of the flag and banner crew job. The gentleman climbing up carries a seat cushion and his band instrument.

After all band members and instruments were loaded on the big wagons, Aimee Sporra, Terry Treul, and Donna Peterson from wardrobe collected the ladders. The bands were loaded along Lincoln Memorial Drive and unloaded on the Veterans Park staging grounds. Golf carts, labeled by department, were in heavy demand on parade day.

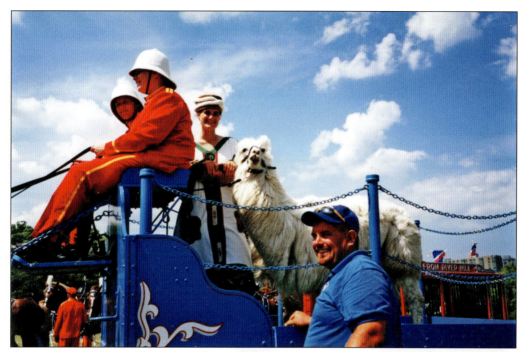

As parade step-off time drew near, all exotic non-cage animals were loaded onto their respective wagons. Randy and Melissa Peterson load a llama via a ramp onto this small wagon. Melissa was a calming presence for the animal as it took in the strange sights and smells along the parade route.

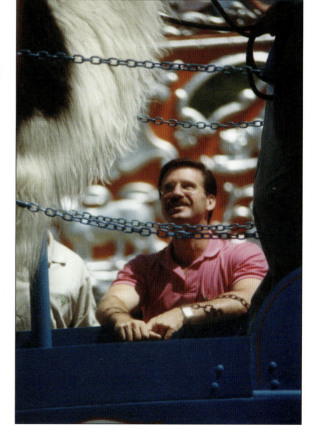

Circus World inherited several Union Stockyard wagons that were modified for various uses over the years. This wagon had poles and horizontal chains added for conveying the llama. Parade director David Saloutos checks on the animals and participants prior to the start of the parade.

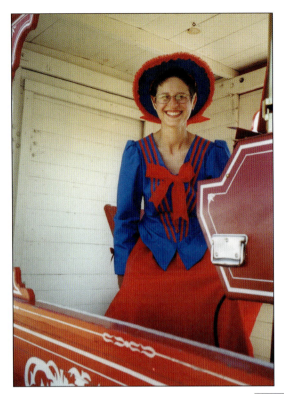

Sara Roltgen wears a period costume and plays the keyboard of an air calliope placed inside the Cole Bros. wagon No. 82. The sides were open, with a picture frame cutout emphasizing the keyboard player. One of the smaller wagons, it was often pulled by a pony hitch.

Volunteering for the parade was usually a family affair. Gretchen Roltgen was seated in a howdah-like enclosure on top of wagon No. 33. A Una-fon circus instrument was hoisted on top of the Sparks wagon specifically for the parade. This unique instrument was made up of a series of tuned doorbells hooked to a keyboard and powered by a car battery.

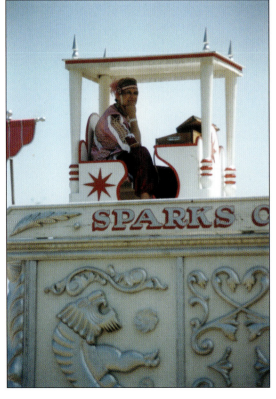

The safest way to reach the top of any wagon was by ladder. On parade day, a banners and ladders crew member holds the ladder for a participant to climb up. Because the horses had to be hitched and ready to go an hour before step off, riders often waited until the last possible minute to take their places.

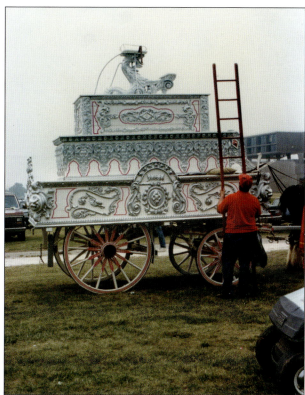

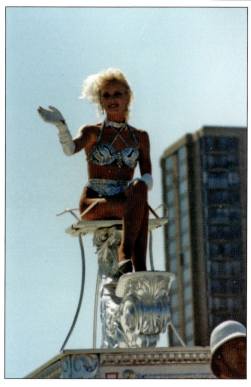

Kathy Hayes is strapped to the seat at the top of the English Star tableau. She was perched high above the teamster's head, as seen in the bottom right corner. Riding a wagon was a bumpy ride at best. This wagon was different, featuring silver carvings and pink trim.

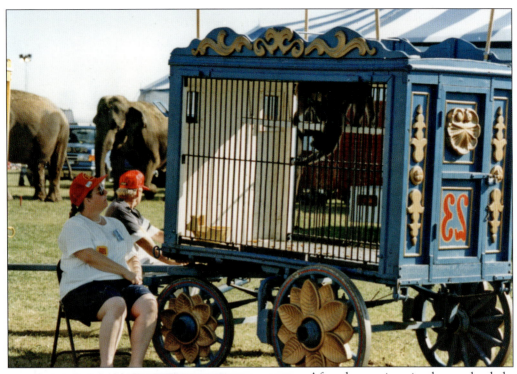

After the exotic animals were loaded into their respective cage wagons, the wagons were moved to a central spot for hitching. Each wagon had one to two volunteers whose only duty was to keep spectators away from the cages. While this volunteer keeps an eye on the monkey on the upper bar, the gentleman behind her keeps a watchful eye on the roped-off elephant area.

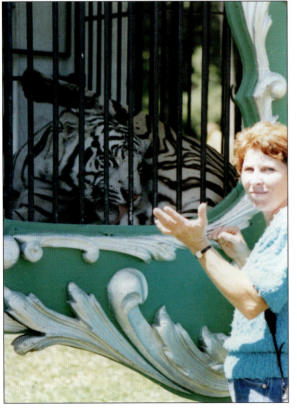

Trudy Strong, standing by a wagon holding two of her white tigers, is from a renowned circus family that has performed all over the United States and Europe. The green wagon with silver carvings is referred to as the Picture Frame wagon. All the animals were given plenty of water and food for the parade.

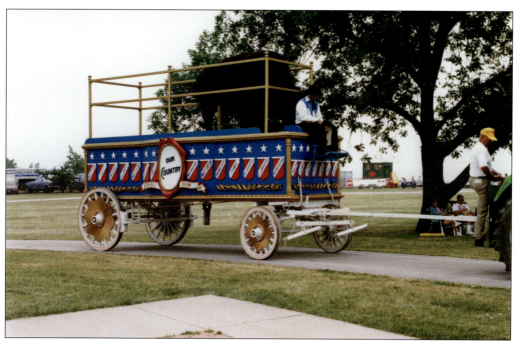

Historically accurate when built, the Our Country tableau wagon lists only 48 states. Over the years, riders varied—from Betsy Ross to first presidents, the Statue of Liberty, and a longhorn steer and buffalo. For animals, the gold railing was added. The day before the parade on July 12, 1995, a city inspector decided one bar was not high enough to keep the buffalo contained. Crew welders worked throughout the night adding the second lateral bar.

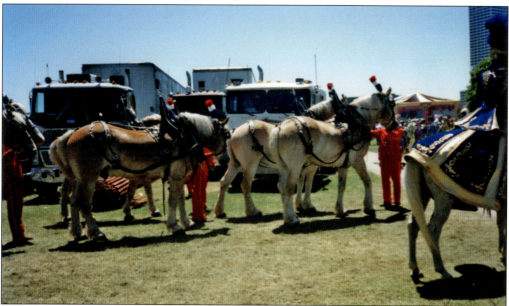

Harnessed with red, white and blue plumes, this team of Belgians is being led out to Lincoln Memorial Drive for hitching. Leaving the horse tents, the horses passed by the riding units and around the caged animals on the journey to their wagon. Horses had Vicks VapoRub smeared in their noses to prevent them from spooking if they smelled the tigers and bears.

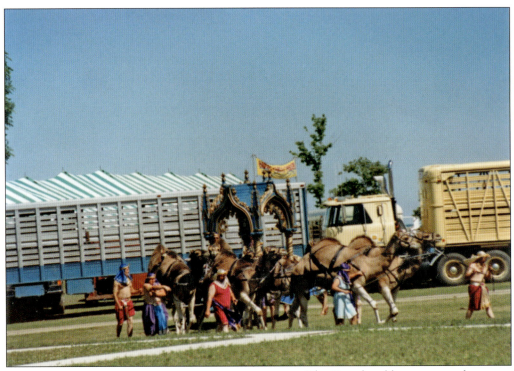

The Temple tableau was another unique wagon, with four columns to support a large canopy. Traditionally, a young lady sat on it with a tiger, leopard, or bear on a leash. This year, the blue tableau wagon is pulled by a hitch of 20 camels owned by David "Dave" Hale. The handlers are costumed in colorful Arabian outfits.

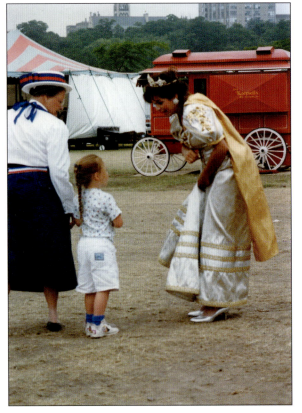

Cinderella, Annemarie Felkofer Pierce, visits with a participant's granddaughter prior to parade time. As Cinderella, Pierce would ride in a carriage pulled by a pony hitch. Over the years, the hitches varied in length from six to eight ponies. It was in the children's section of the parade.

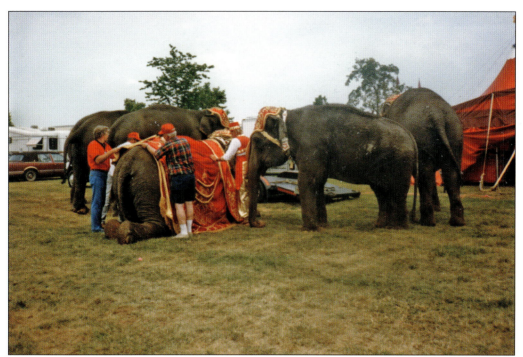

A herd of elephants wearing headpieces moves in to receive blankets. Once the elephant knelt down, it took four people to put the blanket just right on the animal. In this picture, there are three wardrobe volunteers and the handler putting on the elephant blanket.

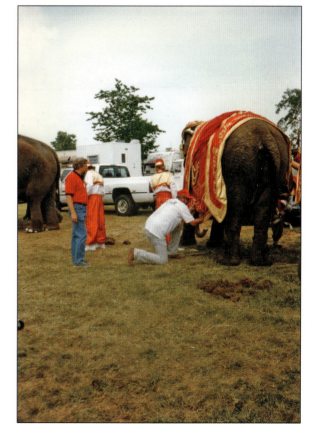

Frederick "Fred" Reagan looks on as Sid Nyholm fastens the elephant blanket strap. The elephant had its headpiece put on earlier, and the blanket is the last part of the costume to go on. There could be up to three different herds of elephants in the parades.

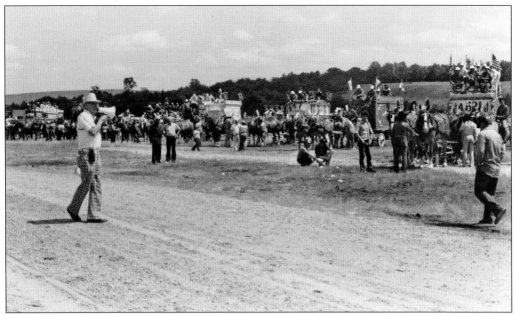

Teamsters are hitched and ready for the 1980 parade in Baraboo, Wisconsin. Bob Parkinson, with the bullhorn, speaks to the assembled teamsters just prior to step off. Milwaukee Schlitz parades were held from 1963 to 1972. After an eight-year break, the Baraboo parade started a new tradition that continued in Milwaukee until 2009.

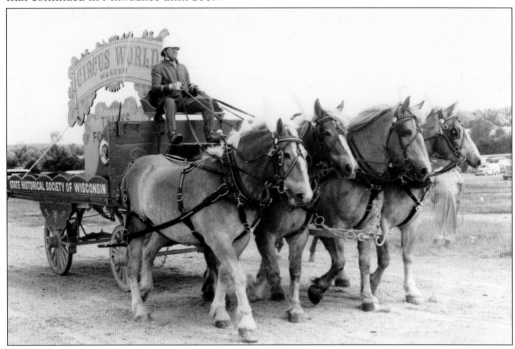

The Introductory wagon leads off the parade in 1980. Lyle Getschman of Baraboo, Wisconsin, steps off with a unique hitch of four abreast Belgian horses. Traditionally, four-horse hitches were two by two. The Getschman family lived near the museum and were often called upon if a wagon needed pulling in a local community parade.

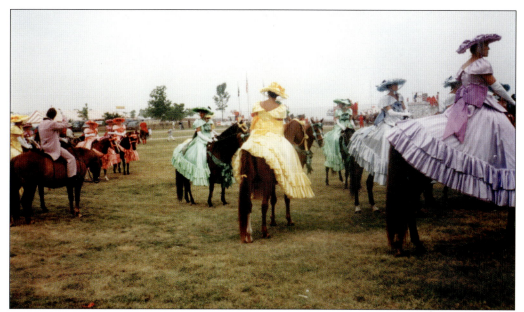

The Rainbow Equestrians walk their horses in the riding-unit staging area. When the group stepped off, they were in rows of purple, pink, blue, green, and yellow. The riders would put on their costumes and get up on their horses, and then several wardrobe volunteers would add the matching skirt. The gentleman in the lavender suit on the far left was an outrider for the group.

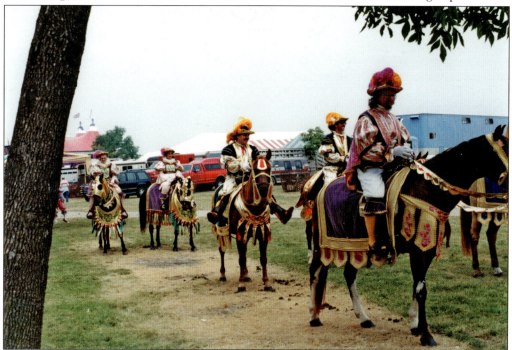

The costumes for the riding horses were quite elaborate. Often, there was a bridle cover, a line cover, the breastplate, and the horse blanket. Many had large rhinestones sewn on that caught the sun and sparkled along the route. The riding-horse participants would pick up their own costumes and then go to baggage wagon No. 29 for all their horse costume pieces.

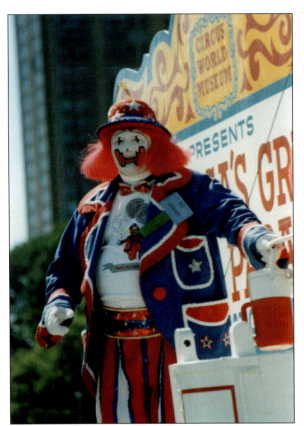

James "Jimmy" Williams, dressed as Happy the Clown, rides the introductory wagon. In 1996, Happy the Clown celebrated 30 years with Circus World Museum. For this parade, he had the day off from performing and was honored for making children of all ages laugh for 30 years.

The first leg of the parade for all units was a large hill. Here, the Great Britain bandwagon that is being pulled by a six-up crests the hill. Because the hill was so steep, a train crew member with a follow-up chock ran halfway up the hill and a second follow-up chock crew member followed from the midpoint to the top for every wagon.

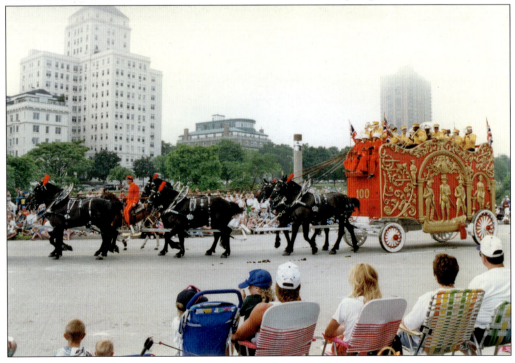

Tu-Tall the Giraffe enjoys the ride as his wagon parades past the crowd. The Ringling Giraffe wagon No. 93 did not originally have a shade top; the middle of the wagon dropped down, and the top was open so the giraffe could stand at full height and enjoy the ride.

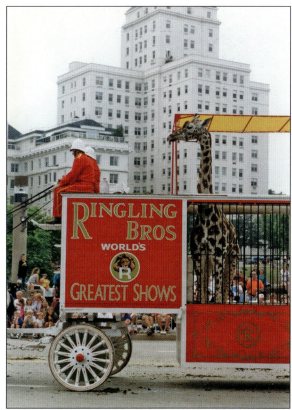

Before the last wagon starts up the hill for the parade, the first wagons are coming back in. The Bostock bandwagon, pulled by Merle Fischer's 13 Percherons, was unique. The hitch had each horse pulling nose to tail in a single line of 13 horses.

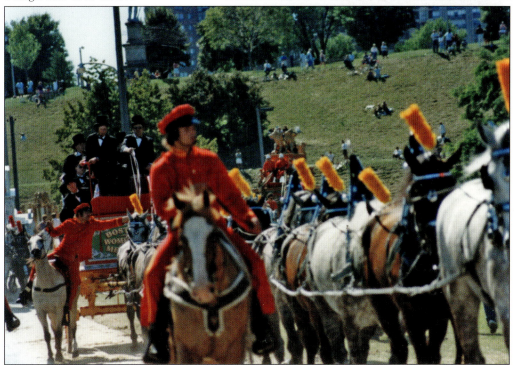

When wagons returned from the parade, the grounds flag and banner crew retrieves all banners. Riders on top of the wagons were happy to toss them down to waiting volunteers. The white boxes in the middle of this picture are the plume boxes. Teamsters checked in their red uniforms and plumes all in one corner of the wardrobe area.

Wagon No. 70 was the wardrobe wagon that housed the wagon flags, banners, and horse plumes. For travel, the banners were banded in sets of four on the top left side. Large flags were rolled and banded on the right side. After everything was tied down, the entire floor was packed with plume boxes. Cally Hensersky holds a banner that came in from a wagon.

Four

Heading Home

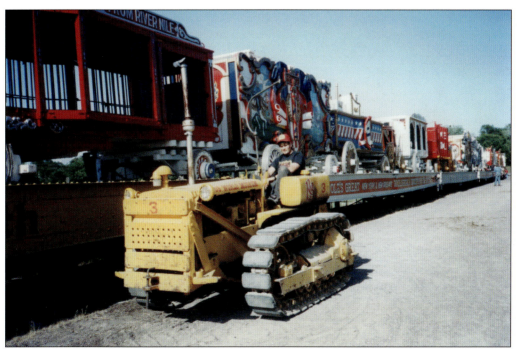

The second cut of loaded train flats is loaded and ready for the switch engine to move it to the assembly track. The Caterpillar tractor driver, Christopher "Chris" Peterson, drives along the back side of the train headed toward the run car. Mechanical equipment such as Caterpillars was loaded on the last cut together so those flatcars would be the first unloaded when back in Baraboo.

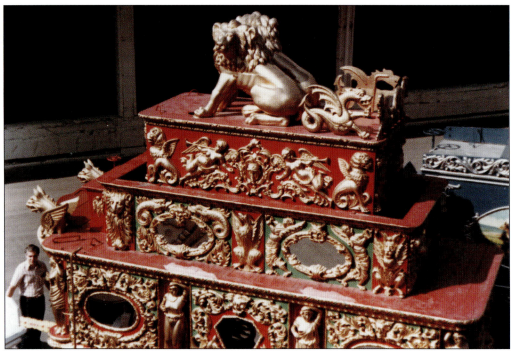

The English Twin Lion Telescoping wagon sits on Navy Pier in Chicago after the parade. Before it was caravanned to the train-loading area, the top layer had to be lowered. The wagon was too high to fit under bridges along the train route.

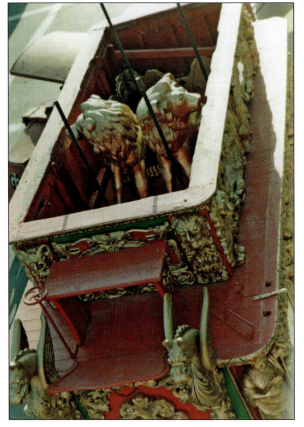

The lions were raised or lowered by use of the four threaded rods. There were crank handles carried inside the wagon body, and the top tier was lowered down inside the body of the wagon by slowly turning the crank handles. Once lowered, the highest point on the wagon for transport were the four rods in the picture.

In 1981, the horse teams were all tethered on the second level of Navy Pier in Chicago. After the parade load out started, trucks came up the south ramp. They were loaded and driven east to the far end of the pier. The drivers negotiated a tight curve and headed back on the pier's north side. In this photograph, Richard "Dick" Sparrow's 40-horse hitch semitruck is parked to load.

The wagons were caravanned to the train yard for loading. Left behind for the cleanup crew were all the big "kitty litter boxes." A plastic sheet was placed on the ground with wood squares measured to fit under the various sized wagons, and sawdust was put on the plastic. Cage wagons with animals were parked over the boxes for sanitation.

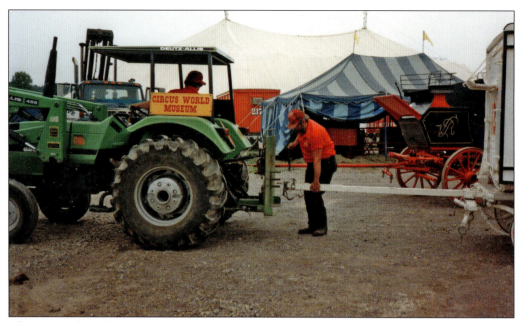

This tractor driver has backed up so the pinner can pin the wagon pole in place. Once the wagon is secured, the pinner will climb on the rear of the tractor and ride along to the wagon parking spot. After the parade, all wagons are assembled in caravan lines. At the destination, the pinner unpins the pole. The process continues until all wagons are spotted.

The side walls are tied up to allow cool breezes from the lake. The tents are 200 feet long, and each contains 76 draft horses; however, the horses have left the tents and are headed home. Big hitches drop wagons up the center midway after the parade. The pipe in the foreground is connected to a city water main to provided ample water for the teams.

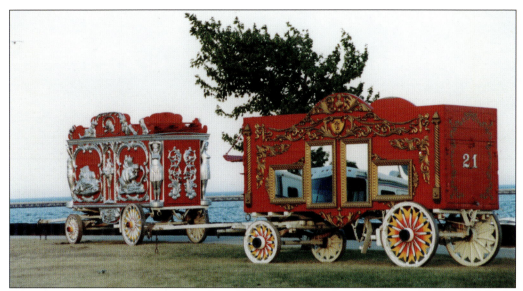

Teamsters with smaller hitches often dropped their wagons along the lake wall. On the left, the red and silver Lion's Bride wagon, along with the Gollmar Mirror wagon on the right, were left along the lake wall and across from the teamster campground. Campers are reflected by the mirrors on the Gollmar wagon.

Bill Dexter works in the wardrobe department. He hammers a wood chock block to the floor, which kept the big red wooden boxes of costume accessories from bouncing around on the train ride home. While the train crew moved and loaded the parade wagons, the wardrobe crew hustled and packed up all the wardrobe wagons.

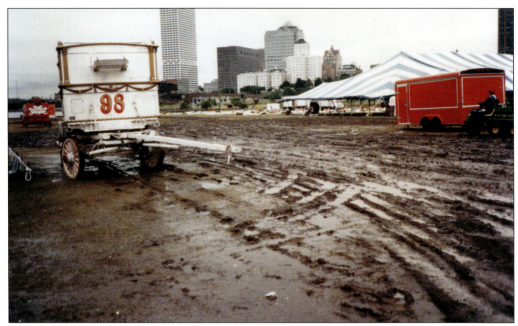

When dry, the parade grounds was a grassy lot. While the parade was brought in on a dry day, there was a torrential downpour the night before this picture was taken. As crews were moving the wagons and emptying the horse tents of heavy chain, A-frames and stakes could really chew up the grounds. Crews were banned from using the center midway, and all traffic had to move around the outside.

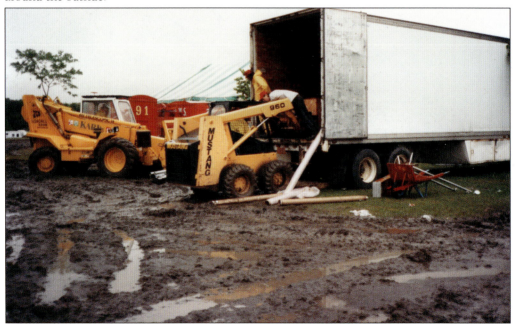

Two long semitrailers were used for years to haul equipment such as signs, tent poles, carpeting, and boxes of stakes and A-frames, which were used to create the horse tethering lines for all tents. The plastic containers that hold the equipment were picked up from the horse tents and loaded into the trailer by a Bobcat and a front-end loader.

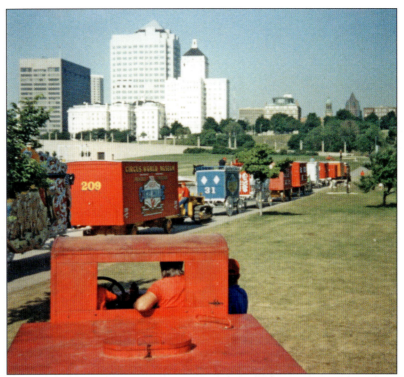

The first wagon convoy leaves Veterans Park, bound for the train yard. A motorized vehicle pulled three to four wagons, depending on the weight of the wagons and the wagon build. Not all wagons had a hitch on the back where another wagon pole could be attached. Police escorts led and brought up the rear of the convoy as it negotiated morning rush-hour traffic the Monday after the parade.

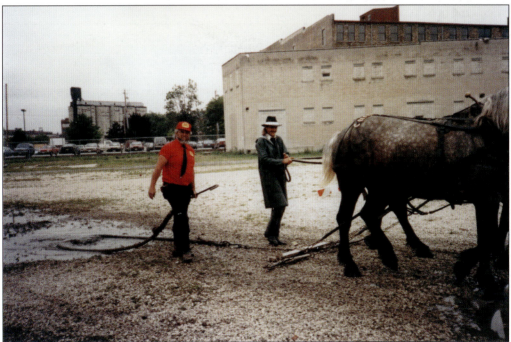

Three teams of horses were used to load the train: the pull-up team, the pull-across team, and the chock team. The pull-across team of two draft horses, a teamster, and hook roper decided to lighten things up by dressing formally on a cloudy day after the parade. A dapper hat and tie had the entire crew in stitches.

83

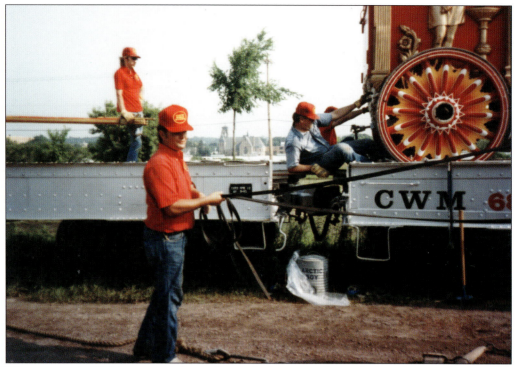

The teamster holds his team steady, ready to jerk the wagon forward when the two chock setters at the back of the wagon give the command. The chock setters hold on to rings on the back of the wagon with their feet up against a back-wheel chock block. When the wagon moves forward against the front chocks, they will push the back chocks into place. Another poler waits to guide his wagon into position.

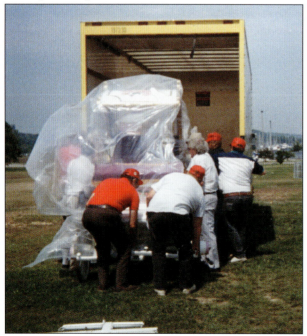

Circus World received a Cinderella coach wagon that was used in the Ringling Bros. and Barnum & Bailey shows. It is covered with plastic because of the fabric cushions on the seat. A Ryder truck was rented to transport this wagon. The ground crew lifts it into the truck, as there were no ramps.

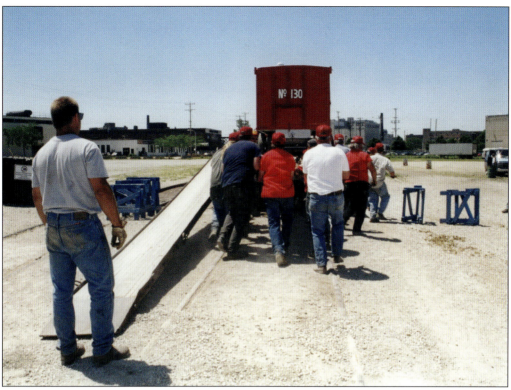

The entire train crew lifts the right ramp to the center of the flatcar and then proceeds to push the ramp down the center of the car. In circus parlance, this was referred to as "shooting the runs." The second ramp on the left followed. As the ramp moves forward, the front crew members jump out of the way so the guys on the back end can keep the momentum going. The harder they push, the farther down the flatcar it travels. After both ramps are on the flatcar, the crew places the blue jacks between the wagon wheels, chocks, and runs.

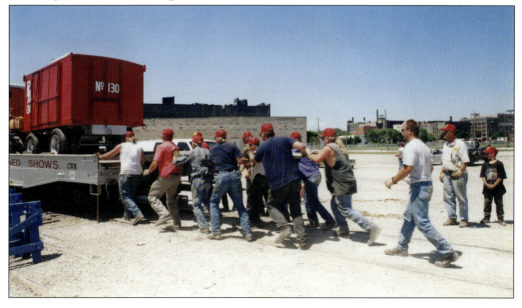

The loaded train was moved to an overnight holding spot until departure early the next morning. Once spotted for the evening, the horses were brought out of the stock car and tethered to the side. Half are in this picture, with the rest on the other side of the loading ramp. Two teamsters and an emergency crew stayed overnight in the trailer at the end of the train.

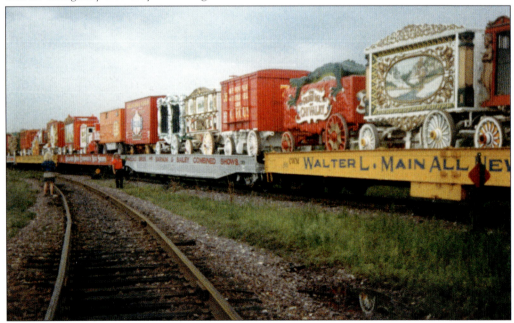

While it took two days to bring the wagons down due to all the dignitaries and stops along the route, the return trip was completed in one long day. The horses are loaded into the stock car, and the majority of the train crew travels back to Baraboo on the train. No other passengers rode back.

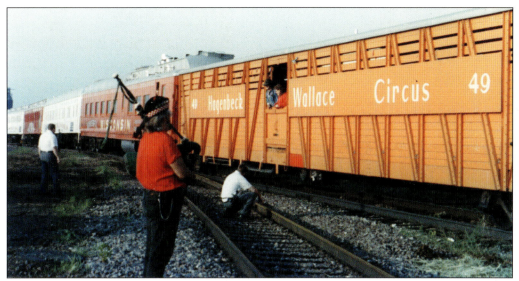

As the train pulls out of Baraboo at the start of circus week, crowds gather and a circus band plays as the train departs. When the train pulls out of Milwaukee, very early in the morning, there are no crowds. To salute the hardworking crew who had another leg of the journey to complete, a bagpiper plays the traditional Scottish song "Going Home." It became an annual and expected crew tradition.

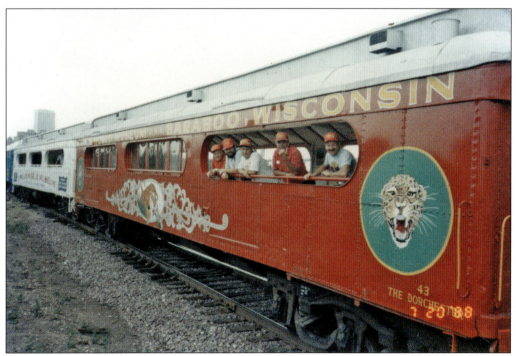

On the morning of departure, the only passengers riding back to Baraboo are the train crew. Crew members ride in the stock car, the passenger car, and the end caboose, and all enjoy the musical salute by the bagpiper. The train kept a slow speed of 25 miles per hour to keep the wagons from rocking and jerking. Several chock stop checks were also scheduled along the route.

The Great Circus Train had its very own bay window caboose. It was painted in patriotic red, white, and blue and had logos on each side for the Circus World Museum and the Great Circus Parade. Safety stops were scheduled along the route. The crew in the caboose would get out and walk the length of the flatcars, checking that all chocks were secure.

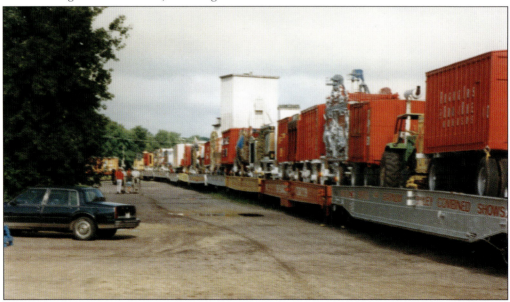

The Great Circus Train arrives home in Baraboo, Wisconsin. A switch engine gently pushes the loaded flats onto a siding track for unloading. After the first flats are moved into position, the train engineer will unhook, leaving seven cars to be unloaded for the first cut.

Before unloading begins, James "Jim" Sherman poses in front of the flat. Sherman was a Circus World employee proud to see the antique collection back home. On the flat behind the Caterpillar tractor is a rubber-tire band organ that made the trip to Milwaukee.

The first cut of wagons has been unloaded. The switch engine moved the empty flats off to a siding and then brought another cut in for unloading. In the background, a stock car is parked on a separate siding track. In the foreground, the Caterpillar and tractor drivers wait for the start of another unloading cut.

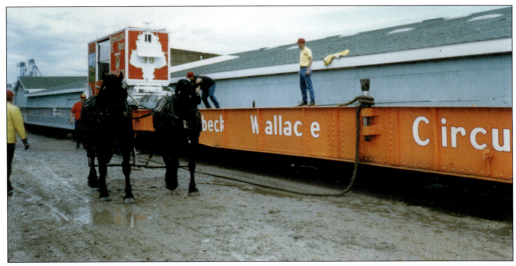

This team of black Percherons pulls the giraffe wagon down the string of empty flats. Standing on the gunnel in the yellow shirt is Steven "Steve" Mader. He watches as the poler keeps the wagon straight. In the middle of the flatcar side, there is a heavy spool with rope loosely wrapped around it.

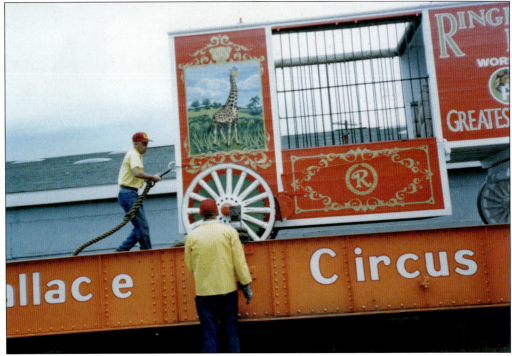

When the wagon passes Mader, he hooks the rope onto the wagon's rear mud ring. Richard "Dick" Britton slowly feeds the rope out as the wagon begins down the runs. With the poler still guiding the wagon down the ramps, Britton's rope acts as a brake lever to stop the wagon's movement at the end of the ramp.

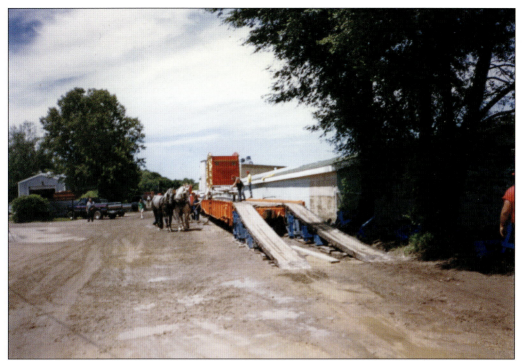

The pull-along horse team pulls the wagon across the empty flats toward the run car. The hook roper stands on the gunnel, waiting for the wagon to pass. This was the last wagon of the cut. The crew took a break while the last cut of loaded flats was moved into position.

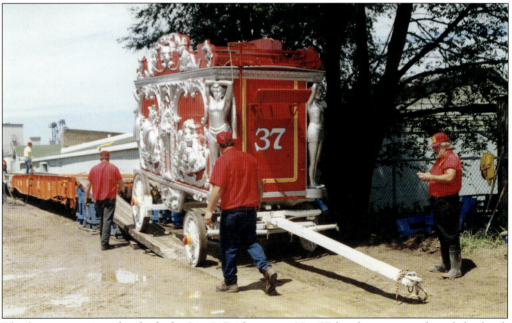

The horse team is unhitched, the Lion's Bride wagon No. 37 has been stopped, and the hook rope has been walked back to position for the next wagon. The wagon waits for a tractor to come, hitch up, and move it down to the museum grounds.

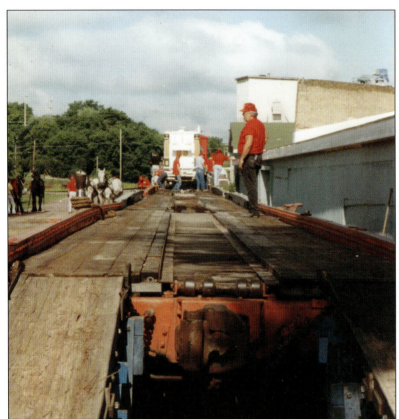

The train crew pries chocks free from the front and back of the wagon wheels. The poler puts the pole into position, and the pull-across team gets ready. The indentation in the center of the run car is the slot that the runs are pushed into when the unloading is finished.

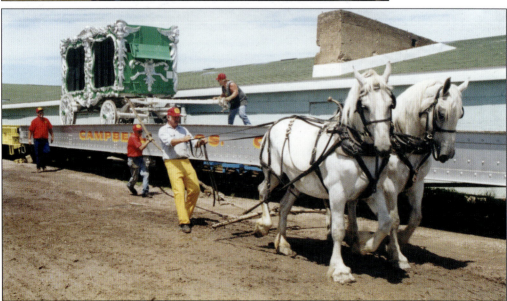

Wagon superintendent Harold "Heavy" Burdick watches carefully as the Picture Frame wagon is pulled across the empty flats. The wagon is pulled by a team of white Shire draft horses owned and driven by Nolan Darnell. Darnell and his family traveled from California to work for Circus World and pulled a wagon in the Milwaukee parade.

The office tent top has been unloaded across from the wagon barn at Circus World Museum. The rolls of vinyl tent are laid out flat and then braided together. The tent top was used at that time for company picnics and other gatherings.

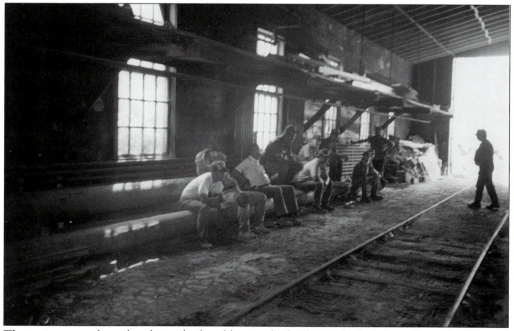

The train crew takes a break inside the old train shed. This is the building where the flats and coaches are stored in the off-season. The coaches were kept on the center track, and the flatcars sat on the two outer tracks. The crew waits for the semitrucks to arrive for unloading.

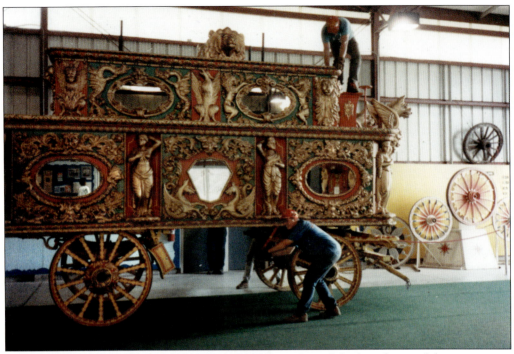

One of the last chores of the train crew was respotting all the parade wagons. Wagons were returned to their original positions prior to the start of the Great Circus Parade. The English wagons were cranked back up to their full height. Two crew members on each side of this wagon slowly crank up the top, while the person on top watches and guides it.

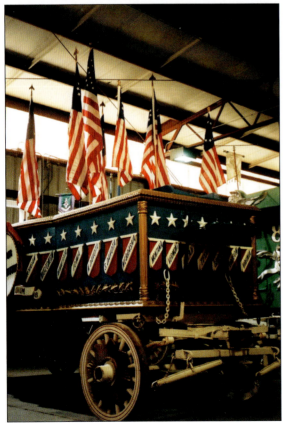

Our Country wagon is back in the pole barn. All its American flags are put back on top. Banners were also brought out of baggage wagon No. 70 and repositioned on their respective wagons. Circus World Museum has the largest collection of antique circus wagons in the world.

The wagons are back home safe and sound, and Edward "Ed" Lester is satisfied with the Circus Parade run. This was a high compliment, as he was a longtime, highly respected member of the train crew. Lester was the most knowledgeable and experienced crew member when it came to loading and unloading trains. He worked for many years as a consultant for the Royal American Carnival as its wagon master. In addition to his full-time job as an engineer, he traveled to the carnival's current location at the end of a date. He gave the loading order for all the carnival wagons and equipment and had all the wagon lengths and flatcar lengths memorized. Each time the carnival date came to an end, as the wagons came to the train tracks, Lester told the crew which wagons to load in what order.

DISCOVER THOUSANDS OF LOCAL HISTORY BOOKS FEATURING MILLIONS OF VINTAGE IMAGES

Arcadia Publishing, the leading local history publisher in the United States, is committed to making history accessible and meaningful through publishing books that celebrate and preserve the heritage of America's people and places.

Find more books like this at
www.arcadiapublishing.com

Search for your hometown history, your old stomping grounds, and even your favorite sports team.

Consistent with our mission to preserve history on a local level, this book was printed in South Carolina on American-made paper and manufactured entirely in the United States. Products carrying the accredited Forest Stewardship Council (FSC) label are printed on 100 percent FSC-certified paper.